British Art Show 8

Anna Colin & Lydia Yee

Leeds Art Gallery
9 October 2015 – 10 January 2016

Scottish National Gallery of Modern Art,
Inverleith House, Royal Botanic Garden Edinburgh,
and Talbot Rice Gallery, University of Edinburgh
13 February – 8 May 2016

Norwich University of the Arts
and Norwich Castle Museum and Art Gallery
24 June – 4 September 2016

John Hansard Gallery, University of Southampton,
and Southampton City Art Gallery
8 October 2016 – 14 January 2017

SOUTHBANK CENTRE **HAYWARD PUBLISHING**

4 Foreword

7 Anna Colin: The Capacity of Things

11 Lydia Yee: On the Subject of Objects

16 Åbäke

20 Lawrence Abu Hamdan

22 Caroline Achaintre

26 John Akomfrah & Trevor Mathison

28 Aaron Angell

30 Pablo Bronstein

32 Adam Broomberg & Oliver Chanarin

36 Andrea Büttner

38 Alexandre da Cunha

40 Nicolas Deshayes

44 Benedict Drew

46 Simon Fujiwara

50 Martino Gamper

53 Roundtable on Production

60 Ryan Gander

64 Melanie Gilligan

66 Anthea Hamilton

68 Will Holder

70 Alan Kane

72 Mikhail Karikis

74 Linder

78 Rachel Maclean

80 Ahmet Öğüt with Liam Gillick, Susan Hiller, Goshka Macuga

82 Yuri Pattison

84 Ciara Phillips

86 Charlotte Prodger

88 Laure Prouvost

91 Roundtable on Social Relations

98 Magali Reus

100 James Richards

102 Eileen Simpson & Ben White

104 Daniel Sinsel

108 Cally Spooner

110 Patrick Staff

112 Imogen Stidworthy

114 Hayley Tompkins

116 Jessica Warboys

120 Stuart Whipps

124 Bedwyr Williams

126 Jesse Wine

128 Lynette Yiadom-Boakye

132 List of Works

140 Author Biographies and Acknowledgments

Foreword

Now in its eighth incarnation, *British Art Show* has a well-established record as the most significant and ambitious exhibition of contemporary art being made in Britain. Organised every five years by Hayward Touring, it has introduced new generations of British artists to millions of people across the country; since its launch in 1979, editions of *British Art Show* have been presented by 60 different galleries in 15 cities, and we are very pleased that this latest edition will be hosted by our partner galleries in Leeds, Edinburgh, Norwich and Southampton. Combining a tightly focused and provocative argument with a rich diversity of works, it showcases the wealth of skill, inventiveness, humanity and humour prevailing in British art today.

British Art Show is a highly collaborative project, beginning with our relationships with the partner galleries in each city. The exhibition's curators are selected through a process of research, debate and discussion among all the participating galleries. The curators of *British Art Show 8*, Anna Colin and Lydia Yee, were chosen by unanimous agreement: they bring to the task exceptional qualities and experience that complement and reinforce each other, and share a seriousness and passion for contemporary art, informed by an international perspective. The exhibition they have composed is remarkably ambitious for a touring show: 26 of the 42 artists are producing new work and a number of these entail co-commissions and collaborations with other organisations.

British Art Show 8 has benefited from generous support from Arts Council England's Strategic Touring Programme. Working closely with our partner organisations, and with the benefit of their knowledge and expertise, we have been able to produce a wide-ranging programme of audience development activities that extends the reach of the exhibition well beyond the galleries. A variety of creative outreach projects, some led by artists in the exhibition, will be held in each city, with a specific focus on areas with poor cultural provision. Community groups are to be provided with the resources and training to generate events in response to the exhibition and the issues it raises.

The Strategic Touring Programme grant has also funded the creation of a specially designed *British Art Show 8* website, britishartshow8.com, an interactive digital platform that enables us to communicate with the widest possible public and invite them to respond directly to the themes of the exhibition. As well as information about the exhibition and the artists, the website hosts a blog featuring regular posts from artists, curators and writers in residence. As the exhibition tours the country, this website will be 'owned' and managed by each city, providing a place to capture events, activities and stories, allowing online visitors to gain a unique experience of *British Art Show 8*.

In addition to the special artists' projects funded by the Strategic Touring Programme, a number of the new commissions in this *British Art Show* engage imaginatively with the public in ways that expand the notion of an exhibition as simply an aesthetic experience. From projects that engage local artisans and former employees of a motor works to an artist-led campaign to alleviate student debt, these outward-facing initiatives will bring an enhanced civic dimension to the exhibition.

An exhibition that tours to multiple sites is, by its nature, an exercise in transformation; it takes a different shape in each city, with new configurations and relationships between works and changing atmospheres inflected by the distinct character of each of the myriad galleries. The variety of spaces and contexts on this *British Art Show* tour is especially stimulating. In Leeds, the Art Gallery is the sole venue. In dedicating the whole building to *British Art Show 8* (apart from one gallery of Victorian paintings), Leeds Art Gallery has demonstrated a determination to rise to the many challenges of opening this complex multi-media exhibition. In Edinburgh, a city with a history of cross-site festivals, the show will be presented by three different galleries, all with well-established reputations for exemplary presentations of contemporary art. Norwich will host the first *British Art Show* to have been shown in East Anglia, in two contrasting settings: an extraordinary museum steeped in history and an art school reinvented in the twenty-first century as a successful and forward-thinking university of the arts. In Southampton the exhibition heralds the opening of the new John Hansard Gallery, relocated from the University of Southampton Highfield Campus to a new site in the city centre.

We are very grateful to the many organisations and individuals that have contributed to *British Art Show 8*; a full list of all those involved appears in the Acknowledgements section of this catalogue. In the limited space available here, I would like to offer our special thanks to all of the artists, who have responded to our invitation to participate with generosity and imagination. The curators have also earned our gratitude and respect: they have given careful thought to every decision along the way and the result is a fascinating and original exhibition. Among those who have played a crucial role in bringing the exhibition to fruition, we owe our profound thanks to our colleagues in the four host cities who have taken a keen interest in every step. In addition, I would like to thank all the members of the Hayward Touring curatorial team, who have organised this complex show with consummate proficiency and dedication. Finally, we are indebted to Fraser Muggeridge studio for giving a fresh graphic face both to the identity and to this catalogue.

Roger Malbert, Head of Hayward Touring

Anna Colin

The Capacity of Things

Thirty-six years after the inception of the *British Art Show*, and eight editions down the line, the number of artists who qualify as British has never been so high, making the task of surveying the British art scene more ambitious than ever. Meanwhile, if the national survey exhibition has served an important purpose – to make sense of and introduce a wide public to recent tendencies in contemporary practice – it arguably remains a form that needs revitalising, notably in light of an increasingly globalising art world. It is therefore a major challenge to curate an exhibition that is broadly representative of current British art, while being conceptually coherent and provocative, both for a public new to the work presented and art audiences familiar with recent developments.

While Lydia Yee and I have chosen to work with 42 artists, this number constitutes by no means the breadth of practices we feel represent current trends in British art. Instead, the list of invited artists reflects a curatorial process that began in an open and intuitive manner, and crystallised as practices, motifs and concerns started to coalesce. A key area that emerged from our conversations with artists, and which came to form *British Art Show 8*'s broad thematic premise, involves new thinking around materiality: how artists engage with the material world – whether they work with their hands, archives, people or the Internet – and how they relate to objects and physicality, particularly at a time of increasing convergence between the real and the virtual worlds.

As the research developed, we set a few parameters for our curatorial approach. We resolved to open *British Art Show 8* to practitioners other than visual artists, namely designers who were interesting to us not only for their engaging collaborations with some of the artists in the exhibition, but also for their idiosyncratic relationships with materiality and object making. Furthermore, we extended our invitation to artists who are neither British nor UK-based, but are meaningfully associated with the UK art scene and have contributed to its vitality. Finally, we encouraged the artists to reflect on the contexts of the four host cities, inviting a group of them to respond to a particular site, history, tradition, resource or condition, in dialogue or cooperation with local individuals and groups.

Inspired by the preoccupations of a number of the participating artists, the exhibition's concern with materiality and the relationship between objects is neither specific to the British art scene nor exclusive to contemporary visual art. The reconsideration of objects – or things – and their relations to other entities – be they human, nonhuman, material or immaterial – has been a central concern of philosophy and critical theory over the last ten years. In turn, these debates, which are particularly affiliated with the

speculative realist and (new) materialist schools of thought, started infiltrating art theory and practice some five years ago.[1] Although there are several types of realism in the field of philosophy, and the same goes for materialism, the common thread that runs through both camps is the dismantling of the opposition between subject and object, human and non-human, and the recognition of an objective reality outside what is perceived and conceived in the mind. This recognition not only suggests captivating artistic and theoretical possibilities, but also ethical ones in so far as it serves to de-centre human existence and give value to a biocentric conception of the world as a community of all living things. Taking this discourse to a political, ecological level, theorist Jane Bennett describes 'the capacity of things - edibles, commodities, storms and metals - not only to impede or block the will and designs of humans but also to act as quasi agents or forces with trajectories, propensities, or tendencies of their own.'[2] She provocatively asks: 'How, for example, would patterns of consumption change if we faced not litter, rubbish, trash, or "the recycling", but an accumulating pile of lively and potentially dangerous matter?'[3]

Such theoretical views prove useful in the framing of the exhibition in that they constitute a lens through which to re-evaluate objects, things and materials, and view them in terms of their transformative potential. Furthermore, they provide a framework to explore practices that defy rigid classification and reflect on, emphasise or tamper with distinctions between the material and the immaterial, the physical and the metaphysical, the real and the virtual. Combining all of these concerns, Simon Fujiwara's video *Hello* (2015) also happens to deal with litter. *Hello* conveys two parallel narratives of life and labour: one by Maria, a trash-picker in Mexico, and the other by Max, a German computer animator who was born without arms. A severed hand, designed by Max and evoking a body part found by Maria in the landfill of the violent town of Mexicali, pilots the video. Swiping the screen as one might swipe one's tablet, the hand operates a series of back-and-forth motions between the physical and digital realms, from Maria's story to Max's, from a minimalist set of white plinths on which Maria sits to Max's computer screen, and back again. *Hello*'s clinical and eerie atmosphere conjures up what artist and writer James Bridle has coined 'the new aesthetic', the condition in which digital technology and its visual language are blending with the physical world. Or as film-maker and author Hito Steyerl recently put it, 'the Internet has moved offline'; the real and the virtual now mirror each other.

By making visible 'the entry and exit points of networked technology',[4] Yuri Pattison's work demystifies the digital and virtual spheres, and challenges the incorporeality that they

1. In the last few months alone, as we were developing the exhibition, a plethora of exhibitions, projects and publications directly engaging with this topic has taken place and been published. These include: Christoph Cox/Jenny Jaskey/ Suhail Malik (eds.), *Realism Materialism Art* (New York/Berlin: Sternberg Press and CCS Bard, 2015); *Performance: On Objects*, curated by If I Can't Dance I Don't Want To Be Part Of Your Revolution at LIMA, Amsterdam, 23 June 2015; *Inhuman*, curated by Susanne Pfeffer at Fridericianum, Kassel, 29 March - 14 June 2015; *Vibrant Matter*, curated by Wim Waelput at Kiosk, Ghent, 14 February - 12 April 2015. Earlier significant books, exhibitions and symposia on the subject include: Penny Harvey/Hannah Knox et al. (eds.), *Objects and Materials: A Routledge Companion* (London: Routledge, 2013); *Speculations on Anonymous Materials*, curated by Susanne Pfeffer at Fridericianum, Kassel, 29 September 2013 - 23 February 2014; 'Speculation', *Texte Zur Kunst* 93 (March 2014); dOCUMENTA 13, curated by Carolyn Christov-Bakargiev, Kassel, 16 June - 23 September 2012; *The Anthropocene Project*, a collaborative project developed by Haus der Kulturen der Welt, Berlin (2013-14); and *Animism*, curated by Anselm Franke at Extra City Kunsthal Antwerp, M HKA, Antwerp, Kunsthalle Bern, Generali Foundation, Vienna, and Haus der Kulturen der Welt, Berlin (2010-12).

2. Jane Bennett, *Vibrant Matter: A Political Ecology of Things* (Durham, NC: Duke University Press, 2010), p.viii.

3. Ibid.

4. In the artist's words.

tend to be identified with. While a recent work of his explored a subterranean data centre in Stockholm, Pattison's new piece *The Ideal* (2015) presents footage of a Bitcoin mine in Kangding, Garzê Tibetan Autonomous Prefecture, China. In a remote building located near a power station, high-energy-consuming hardware mines the digital currency Bitcoin.[5] As with several of his previous video works – notably *1014* (2015) which guides us through the Hong Kong hotel room Edward Snowden stayed in following his departure from the USA – the artist has delegated the production of the footage, this time to the Chief Marketing Officer of the Bitcoin startup HaoBTC. Presented as part of a larger video work, and alongside material elements including generic warehouse shelving, computer waste and samples of crude oil, Pattison's work explores the material conditions of the existence of digital networks, revealing their dependency on oil, gas and coal.

In *Damning Evidence Illicit Behaviour Seemingly Insurmountable Great Sadness Terminated In Any Manner* (2014) Cally Spooner also materialises, or even immortalises, aspects of the Internet. Installed on an empty wall, an LED message display serves as a libretto for a weekly opera performance. The scrolling text is taken from YouTube comments including specific events that have caused great upset among different groups of fans: Beyoncé lip-syncing the US national anthem at President Obama's second inauguration, and Lance Armstrong's doping revelations in his interview with Oprah Winfrey, both in January 2013. The comments are arranged by Spooner in such a way as to reflect the hysteria provoked by the incidents, with the artist instructing the a cappella singer to go along this 'roller-coaster of contradictory emotions'[6] as they sing the texts. *Damning Evidence…* raises the issue of trolls to the attention of a museum audience and grounds online content in physical space, dissolving any lingering distinctions between on- and offline reality.

Returning to the world of living, mutating, transformative and socially binding objects, Max's hand, encountered in Simon Fujiwara's video, is one of several objects in the exhibition to have agency. In the show we come across: Melanie Gilligan's Patch, an imagined device of the future that enables people to experience another person's feelings; Laure Prouvost's electric fan, which not only talks, but also momentarily plunges the surrounding artworks into darkness; Lawrence Abu Hamdan's print and sound piece *A Convention of Tiny Movements* (2015), which alludes to everyday objects, such as bags of crisps and tissue boxes, enlisted as listening devices; Imogen Stidworthy's 3-D scan of a piece of bread, which conveys the story of a political prisoner; Anthea Hamilton's connected ant farms; or *Fatima* (2015), Åbäke's ex-voto figure and knowledge receiver and transmitter. Together, these objects insinuate a takeover by the material and natural domain, laying out scenarios for the

5. Bitcoin mining involves running calculations on a computer to verify online payments on a decentralised, peer-to-peer system. Useful information on Bitcoin can be found at bitcoinsimplified.org (last visited: 8 July 2015).

6. In the artist's words.

near future that are alternately provocative, visionary and dystopian Disembodiment and repair are recurring patterns in the exhibition. When Max's hand comes to the fore again, *Fatima* – the Frankenstein-like figure made up of wax body parts bought in the eponymous Portuguese pilgrimage town – is propped for her first exhibition, busy developing a lecture series on the subject of 'evolutive repair'. Meanwhile, Stuart Whipps' 1275 GT Mini from 1979 is to be restored in stages by former Longbridge plant workers, once responsible for the construction of Minis, and exhibited in parts until its complete renovation, which will coincide with the Southampton showing of *British Art Show 8*. Fixing and improving is also central to Martino Gamper's newly commissioned *Post Forma* project, which invites members of the public to bring broken belongings and have them mended by local artisans with whom Gamper has been collaborating. Alerting us to the quality of materials and to the network of social relations these very materials bring about, the artists participating in *British Art Show 8* encourage us to think through the underlying connections between materials, objects, social practice and agency. This tendency is epitomised by two further projects that have been specifically developed for *British Art Show 8*: For *Day After Debt (UK)* (2015) Ahmet Öğüt has commissioned three artists[7] with a particular commitment to politics and education to make sculptures that will serve as donation boxes to relieve student debt; and *Workshop*, an ongoing project by Ciara Phillips that utilises screen-printing to trigger conversations with collaborators ranging from designers to women's groups who have no prior experience with the medium.

From Martino Gamper's dialogue-led repairs to Nicolas Deshayes' self-manufactured objects; from Ciara Phillips' collective making situations to Anthea Hamilton's farms of eusocial and working insects; from Pablo Bronstein's industrial delusions to Melanie Gilligan and Yuri Pattison's visions of digital labour; *British Art Show 8* brings production, labour and collaborative processes into dynamic conversation with the objects' narrative potential and web of relationships. In doing so, it resolutely leaves behind the traditional distinctions between studio-based and less obviously material approaches to work.

7. *British Art Show* alumni Liam Gillick, Susan Hiller and Goshka Macuga.

Lydia Yee

On the Subject of Objects

ART IS NOT A METAPHOR UPON THE RELATIONSHIPS OF HUMAN BEINGS
TO OBJECTS & OBJECTS TO OBJECTS IN RELATION TO HUMAN BEINGS
BUT A REPRESENTATION OF AN EMPIRICAL EXISTING FACT
Lawrence Weiner[1]

A renewed interest in object making among contemporary artists has coincided with the widespread use of digital technologies in recent years. Today's artists are working across a broad spectrum of practices in relation to objects – from research to end products, from the seemingly immaterial to the resolutely physical, from the industrially fabricated to the handmade – and deploy multi-layered processes of making. As a research tool, the Internet has afforded artists unparalleled access to information about new fabrication techniques and an infinite array of files to download and materials to purchase. Arguably, the period between the mid-1960s and mid-1970s was the last major era when artists had such a diverse range of new media with which to work.[2] It was also the moment when the groundwork of current critical discourse around the art object and its production was debated and delineated. Not surprisingly many artists now look to the art of this era as an antecedent to their own practice.

A number of artists in *British Art Show 8* are using materials reminiscent of what Donald Judd described as 'specific' in his influential 1965 essay 'Specific Objects'. Judd championed a new three-dimensional art that is 'neither painting nor sculpture' and extolled the use of 'specific' new industrial materials, such as Formica, Perspex and cold-rolled steel. He was promoting his own art and that of his 'minimalist' contemporaries, including Dan Flavin, Robert Morris and Anne Truitt. 'Materials vary greatly', he proclaimed, 'and are simply materials…. They aren't obviously art. The form of a work and its materials are closely related.'[3] For Nicolas Deshayes, Charlotte Prodger and Magali Reus materials are also specific and closely related to form. Deshayes uses vitreous enamel, powder-coated aluminium and vacuum-formed plastic in his sculptures; Prodger presents her work *Northern Dancer* (2014) on customised cathode-ray tube monitors; and Reus works with a fabricator to supply powder-coated, anodised, phosphated, blackened and etched aluminium and steel components for her series of 'lock' sculptures. Their materials suggest other meanings, such as the relationship of bodies and behaviours to forms and surfaces.

In the mid-1960s, Judd was producing rectilinear volumes fabricated from anodised aluminium and coloured Perspex often presented in modular and serial configurations. 'Actual space', he declared, 'is intrinsically more powerful and specific than paint on a flat surface'.[4] In response, Robert Morris began shifting the terms of minimalism from autonomous forms in space to a decisive

1. Lawrence Weiner, 'Notes from Art', *Art Journal* (42, No. 2, Summer 1982), p.122.

2. The de-skilling of art-making coupled with an interest in commercial and industrial processes led to widespread experimentation with new techniques and materials among artists during the 1960s. Experiments in Art and Technology (E.A.T.) in the USA and the Artist Placement Group in the UK fostered collaboration between artists and engineers, and artists and industry, respectively.

3. Donald Judd, 'Specific Objects', in *Donald Judd: Complete Writings 1959–1975* (Halifax: Press of the Nova Scotia College of Art and Design; New York: New York University Press, 1975), p.181. Originally published in *Arts Yearbook 8* (1965).

4. Ibid., p.184.

emphasis on the relationship between the viewer's body and the sculptural object. Based on his early work in experimental dance and improvised theatre, Morris made sculptures that called attention to the perceptual and spatial experience of viewing art. In 1966, he proposed a reading of minimalism based on gestalt psychology and phenomenology: 'The better new work takes relationships out of the work and makes them a function of space, light and the viewer's field of vision…. One is more aware than before that he himself is establishing relationships as he apprehends the object from various positions and under varying conditions of light and spatial context.'[5] But in 1967 the critic Michael Fried attacked minimalism, believing that 'the literalist espousal of objecthood amounts to nothing other than a plea for a new genre of theatre', predicated on a 'beholder' and a 'sense of temporality', which contravenes 'the presentness and instantaneousness' of modern painting and sculpture.[6]

Both minimalist form and an overt display of theatricality are present in *Damning Evidence Illicit Behaviour Seemingly Insurmountable Great Sadness Terminated In Any Manner* (2014) by Cally Spooner. Most viewers encounter this work as an elongated rectangular black box in the form of an LED surtitle display mounted high on the gallery wall. Scrolling across the device is a libretto composed of nasty comments – 'This is what happens when trash comes to the White House' or 'A dirty cheating bastard' – left by viewers of YouTube videos of prominent figures accused of deceiving the public, such as Beyoncé and Lance Armstrong. A smaller number of viewers experiences the work as a performance; once a week a female opera singer gives a dramatic recital of a six-minute section of the libretto based on one of the scandals.

In a new installation by Anthea Hamilton, theatrical form appears to take precedence over minimal performance. Two-dimensional Perspex cut-outs feature printed images of pop icons in their youth, such as Karl Lagerfeld and John Travolta. The reverse side of each semi-transparent sculpture houses functioning ant farms connected to each other by clear tubes, allowing the ants to move between colonies, animating the static figures. The tunnels and the ants' movements suggest circulatory, digestive, nervous or other bodily systems.

At the same time as North American artists and critics were debating minimalism, the Brazilian artist Hélio Oiticica was also considering the question of the object, formulating a 'New Objectivity', the principal characteristics of which were:

1) General constructive will; 2) a move towards the object, as easel painting is negated and superseded; 3) the participation of the spectator (bodily, tactile, visual, semantic, etc.); 4) an engagement and a position on political, social and ethical problems; 5) a tendency towards collective propositions […].[7]

5. Robert Morris, 'Notes on Sculpture, Part 1', in Gregory Battcock (ed.) *Minimal Art: A Critical Anthoology* (New York: Dutton, 1968), p.232. Originally published in *Artforum* (February 1966).

6. Michael Fried, 'Art and Objecthood', in Battcock, p.125. Originally published in *Artforum* (June 1967).

7. Hélio Oiticica, 'General Scheme of the New Objectivity', in Alexander Alberro / Blake Stimson (eds.) *Conceptual Art: A Critical Anthology* (Cambridge, MA: MIT Press), p.40. This text first appeared in the catalogue for the exhibition *Nova Objetividade Brasileira* (Rio de Janeiro: Museu de Arte Moderna, 1967) and was reprinted in Guy Brett et al., *Hélio Oiticica* (Rotterdam / Minneapolis: Witte de With / Walker Art Center, 1992).

Oiticica's conception of art and objecthood extended beyond the gallery to consider social and political concerns. Like Morris, he worked with dancers, designing *Parangolés* – capes, banners or tents made of painted and layered fabrics and plastic sacks – to be worn and set in motion by dancers from a samba school in a Rio de Janeiro favela. Some were printed with texts, such as 'incorporo a revolta' ('I embody revolt'), suggesting both a rebellion against social and economic disenfranchisement and an opposition to Brazil's military dictatorship.

Nearly five decades later, Linder has created a carpet that is an artwork but also a weighty costume or prop for dancers. Linder's gun-tufted carpet, cut into a spiral and backed with gold lamé, features a psychedelic collage based on two patterns inset with more than a dozen eyes of varying sizes. Working with choreographer Kenneth Tindall, Linder is creating a work with dancers from Northern Ballet who will use the carpet in their performance. Alexandre da Cunha's textile work, titled *Kentucky* (2010), evokes the body in a different way. What initially resembles 1970s macramé fibre art is actually composed of mop heads, the title referring to a style of cotton mop invented in Kentucky in the 1930s, evoking the hard labour of black female domestic workers in the Southern USA and the racial discrimination they faced.

Signalling a departure from the formal strictures of minimalism, critic Lucy Lippard organised an exhibition entitled *Eccentric Abstraction* in New York City in 1966, featuring Louise Bourgeois, Eva Hesse, Bruce Nauman and Keith Sonnier, among others. Lippard wrote that 'the rigours of structural art would seem to preclude entirely any aberrations towards the exotic. Yet in the last three years, an extensive group of artists on both east and west coasts, largely unknown to each other, has evolved a non-sculptural style that has a good deal in common with the primary structures as well as, surprisingly, with aspects of surrealism.'[8] Described by Lippard as organic, erotic and sensuous, the new work made strong references to the body. The exhibition also marked the beginning of a wave of new tendencies – post-minimalism, anti-form, process, performance, feminist art – which culminated in two landmark exhibitions in 1969: *Anti-Illusion: Procedures/Materials* at the Whitney Museum of American Art and *Live in Your Head: When Attitudes Become Form* at Kunsthalle Bern. Within a few years, Lippard would publish *Six Years: The Dematerialization of the Art Object from 1966 to 1972*, focusing on 'so-called conceptual or information or idea art'[9] by artists such as Daniel Buren, Gilbert & George, Sol LeWitt, Adrian Piper and Lawrence Weiner. Was this turn towards language and ideas a disavowal of the object and a gradual progression from form to anti-form to dematerialisation – or did the simultaneity of different practices open up radical new ways to rethink the object?

8. Lucy Lippard, 'Eccentric Abstraction', *Art International* (November 1966), p.28.

9. Lucy Lippard, *Six Years: The Dematerialization of the Art Object from 1966 to 1972* (New York: Praeger, 1973).

Fast forward nearly five decades and we are in the midst of an era in which digital technologies are the most ubiquitous tools in the studio, yet there is a strong desire on the part of many artists to work with their hands, often in a way that emphasises the materiality of their chosen medium. The factured surfaces of Lynette Yiadom-Boakye's introspective portraits of young men and women reveal traces of the gestures of the hand moving oil paint across the canvas. Influenced by German Expressionism, primitivism and other early modern movements, Caroline Achaintre's boldly coloured wall-based works, composed of hand-tufted strands of yarn of varying length, resemble faces, masks and animals. Jesse Wine's large-scale ceramic sculptures and wall works have a roughly modelled surface with imprints left by fingers and palms visible through the glazing.

The return to the handmade object may also be a reaction to the prevalence of the found object in recent decades. When the artists in this show are working with found objects, they are not simply ready-mades, but undergo a transformation or are part of a larger narrative. Daniel Sinsel sources items from the Internet, such as fossilised dinosaur faeces, which he incorporates in the surfaces of paintings that reference the German fairytale 'Hansel and Gretel'. Simon Fujiwara's *Fabulous Beasts* (2015) are made from old fur coats – former status symbols that have lost their value – that he has shaved to reveal a patchwork of irregular pieces sewn together. In her series *Digital Light Pools* (2015), Hayley Tompkins works with stock photography, acrylic paint contained in plastic trays and common objects as surfaces for colour.

Even as seemingly intangible objects as digital files are given a material presence or evoke their referents in the 'real' world. For *Images in Kant's Critique of the Power of Judgment* (2014), Andrea Büttner sources hundreds of images from the Internet and elsewhere as her illustrations for passages in Kant's seminal work *Critique of the Power of Judgment* (1790), which materialise in a set of 11 offset prints. James Richards' *Raking Light* (2014) is composed of found footage and material shot by the artist, mostly resplendent scenes from the natural world but also details of domestic life. The title evokes the process whereby the surface of an object, particularly a painting, is illuminated to examine its condition. The solarisation of segments of the footage lends a uniformity, creating a highly textured film but also suggesting a data defect, a digital artefact that is amplified by an atmospheric soundtrack. A three-dimensional laser scan of porous organic material is the basis for Imogen Stidworthy's video installation *A Crack in the Light* (2013–14). The scan was taken from a piece of rye bread from Aleksandr Solzhenitsyn's last meal in prison before being expelled from the USSR in 1974. The bread,

carried out of Moscow in Solzhenitsyn's pocket and preserved in his archive, instigates a story interweaving the Russian author's biography with his fiction. In another installation, titled *Dodo* (2014), the satirical film *Catch-22*, based on Joseph Heller's novel, is the starting point for Adam Broomberg and Oliver Chanarin's exploration of San Carlos, Mexico, where the film was shot. They have created a quasi nature documentary by re-editing the film's landscape footage, restoring the crowded beachfront to an undeveloped stretch of coastline. Subsequently, they initiated an archaeological excavation to search for the wreckage of a B-25 bomber buried on location, recovering hundreds of fragments of organic and man-made material, including metal parts that could be from an aeroplane.

In recent discourse, not only in the fields of art but also literature, anthropology and history, the study of the object has shifted towards the thing, exploring how objects form and transform human beings. Bill Brown has written: 'We begin to confront thingness of objects when they stop working for us… when their flow within the circuits of production and distribution, consumption and exhibition, has been arrested, however momentarily. The story of objects asserting themselves as things, then, is the story of a changed relation to the human subject and thus the story of how the thing really names less an object than a particular subject-object relation.'[10] The subject-object relationship is overturned by Bruno Latour, who proposes that: 'Each object gathers around itself a different assembly of relevant parties. Each object triggers new occasions to passionately differ and dispute. Each object may also offer new ways of achieving closure without having to agree on much else. In other words, objects - taken as so many issues - bind all of us in ways that map out a public space profoundly different from what is usually recognised under the label of "the political".'[11]

What does this mean for artists, artworks and the public? I close with two examples that make these relationships more concrete. Ahmet Öğüt has commissioned three other artists, Liam Gillick, Susan Hiller and Goshka Macuga, all of whom have taken part in previous *British Art Shows*, to create sculptures to collect donations for an organisation that fights student debt. Martino Gamper invites visitors to bring old shoes, worn clothing and broken chairs to the gallery to be repaired or adapted in unexpected ways by local artisans, highlighting the disappearance of traditional skills and trades. Perhaps, most significantly, these things, like many of the other artworks in the show, offer a chance for people to gather around shared matters of concern. *British Art Show 8* gives us a forum to discuss and debate works representing diverse perspectives on issues we collectively face today and also for the objects to speak to us.

10. Bill Brown, 'Thing Theory', *Critical Inquiry* (Autumn 2001), p.4.

11. Bruno Latour, 'From Realpolitik to *Dingpolitik* or How to Make Things Public', in Bruno Latour/Peter Weibel (eds.), *Making Things Public: Atmospheres of Democracy* (Cambridge, MA/ Karlsruhe: MIT Press/ ZKM Karlsruhe, 2005), p.15.

Åbäke

"I met Fatima when visiting a religious place which I went to without faith, just curiosity. The place happens to be called Fatima too and despite its connection to Lourdes (not Madonna's daughter) there were significant differences in the rituals. Ex-votos made of wax in the shape of body parts could be bought from the shops to thank the powers from above. The process is simple: locate the pain and buy its wax representation in one of the numerous shops before burning it in a public furnace as a thank you for a previous cure or for one you'd hope for. The melted wax is remade into more body parts – minus the inevitable loss during the combustion – in a circle of designed birth and destruction.

"We bought each possible body part to travel with us, creating the possibility to ask the silly questions only idiots, children or a wax figure can ask about life, art and love (as a start). During *British Art Show 8*, Fatima (somewhere between Jeremy Bentham's auto icon and Pinocchio) will meet people who will make her more human or less. As a fragile sculpture with the acquired possibility of memory, repairing her to her original state doesn't make sense. It is unlikely she will become an operating artificial intelligence, but there is no doubt that she will evolve formally due to the encounters she allows. Let's be concrete: she will change from meeting people from whom she'll learn about immortality, the point(lessness) of becoming immortal in form and accepting that being repaired is not necessarily a step backward."

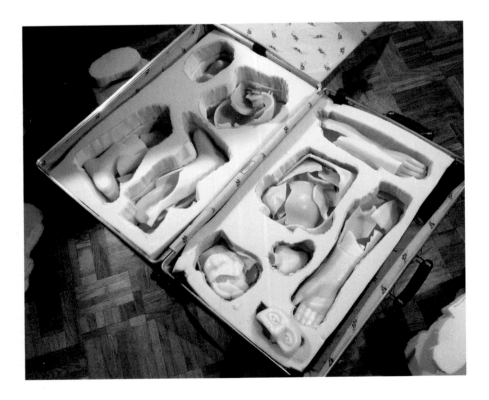

Fatima, 2015
(production image)

Fatima, 2015
(overleaf)
Official Portrait, 2012
Slow Alphabet '4'
(*British Art Show 8 Catalogue*),
2015

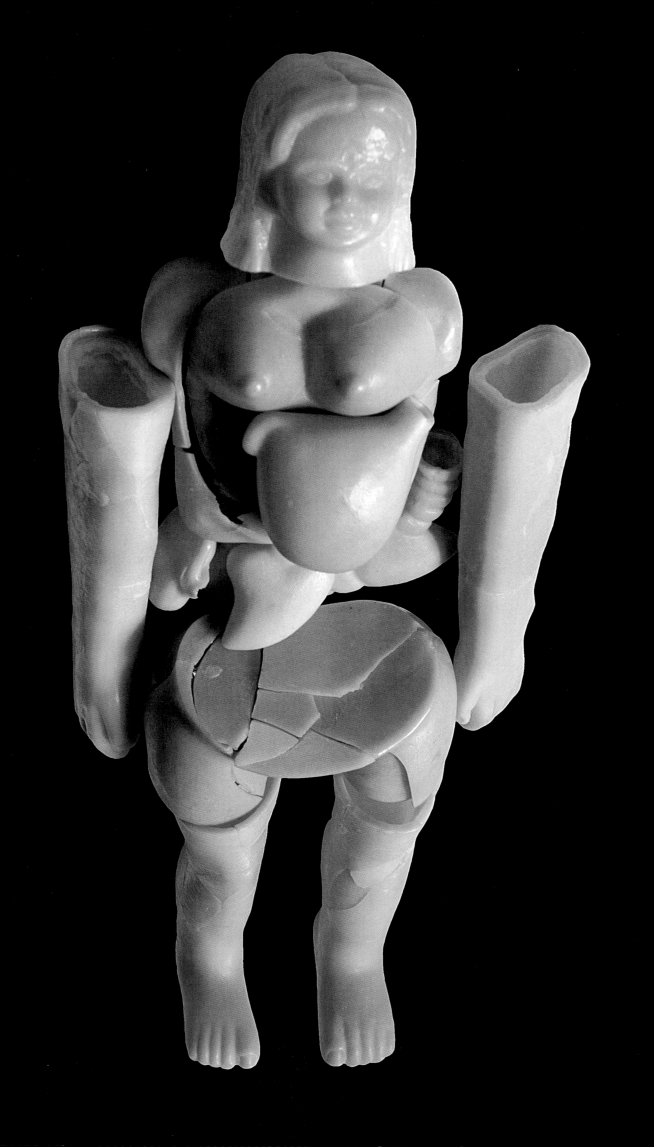

Lawrence Abu Hamdan

The Engineer: In the course of research into the motion of objects, we noticed that certain motions were being caused by sound. So the question arose of whether we could use those motions to figure out what was creating that sound just by looking at the object, creating what we call a 'visual microphone'. And it turns out that it is possible in a number of situations – in fact, it's relatively simple. Normally what you hear is what you record from a regular microphone. Microphones have a diaphragm that readily moves when sound hits it. Electronics record that motion and convert it into an electrical signal, which is interpreted as audio, but is still just motion over time. What we are doing, instead, is looking at an external object, recovering very small motions of that object and interpreting those motions as sound. So if the object is moving on an observable scale in a way that matches the vibrations of the air (which is what the microphone diaphragm does) and we recover it, it will sound just like sound.

The Artist: But you can tell, if you compare the original microphone to the object – to the 'visual microphone' – that it's a male voice speaking, or it's a child's voice.

The Engineer: Yes, we did experiments with objects that don't make great visual microphones, but are OK – boxes of tissues, for instance – where the recovered speech was not intelligible, in the sense that it was difficult to make out what words were being said, but we could still train a computer algorithm to identify the gender of the speaker. In some cases, pitch and cadence are easier to recover than intelligible words. Often you can recover pitch and cadence, but not necessarily intelligible speech.

The Artist: So what is the most successful object as a visual microphone?

The Engineer: It would be something light with a lot of air around it. The object that works the best is the diaphragm of a speaker. Which makes sense, because it's engineered to move in line with the signal of the sound, but it is

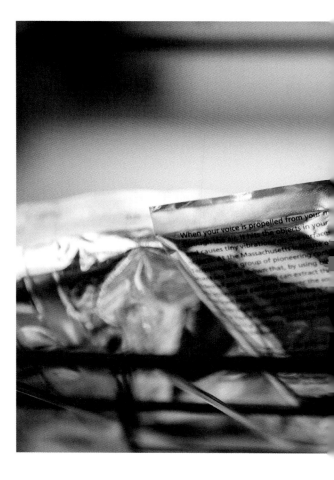

obviously a contrived situation. A bag of chips is quite good. A little piece of tin foil is good. Lindt chocolate bars have this foil on the inside and the foil is very thin and very light; that works very well.

The Artist: What are your ideas in terms of the applications for visual microphones?

The Engineer: The one that the media likes is spying and it could of course be used for that. But in some ways, for me, that's the less compelling application, because, while there are situations where you might be able to recover sound, those situations are limited. What is more interesting to me is what this process teaches us about the properties of objects, in that you get a spatial measurement of how an object is vibrating, rather than a point measurement.

The Artist: So you get another aural perspective on the world.

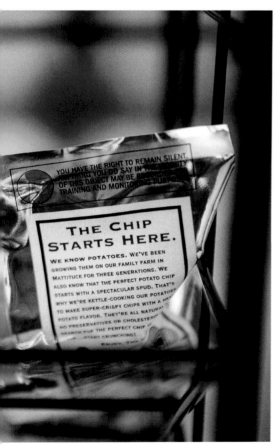

The Engineer: Yes, you hear from the perspective of the object. You almost feel from the perspective of the object. When we think of hearing, we think of what frequencies we are receiving where we are. For the object, it's not just a matter of what those frequencies are, it's a matter of what frequencies the object responds to, which tells you a lot about the object. It's like being at a concert where there's loud music playing, and there may be loud music across all frequencies, but what you feel in your chest is the bass kick. Objects have a similar experience: there are certain frequencies that they're built to respond to.

The Artist: That's interesting. I think we are at a point now where a lot of people are starting to think about how our relationships to objects are changing and how, in fact, that also has deeper implications on the way we think about ourselves. From this 'bass kick' at the concert, one already starts to think about how things are moving differently, moving beyond people. Formally, it is about working with objects and sounds and trying to make environments where people might think about listening differently.

A Convention of Tiny Movements, 2015

Caroline Achaintre

Caroline Achaintre's ceramics and hand-tufted textiles resemble animals with scaly skins or woolly coats. Revisiting the interests of early twentieth-century artists in the power and psychological impact of tribal masks, she creates compositions that oscillate between abstraction and figuration as well as two and three dimensions. Their anthropomorphic features are animated in wide grimaces and expressive stares.

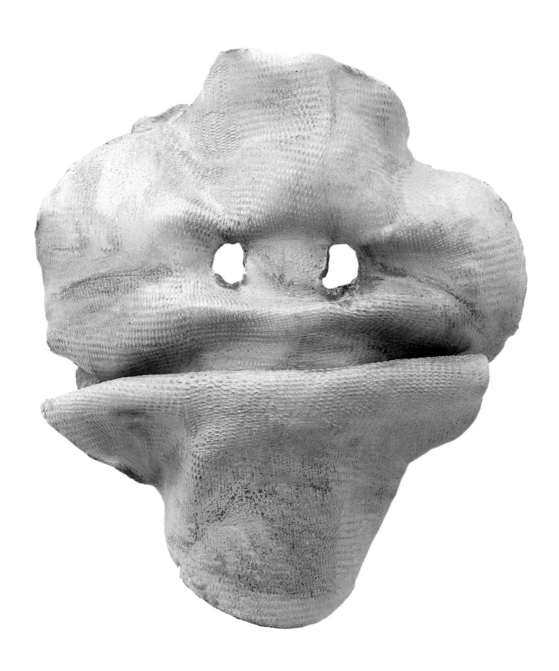

Skwash, 2014

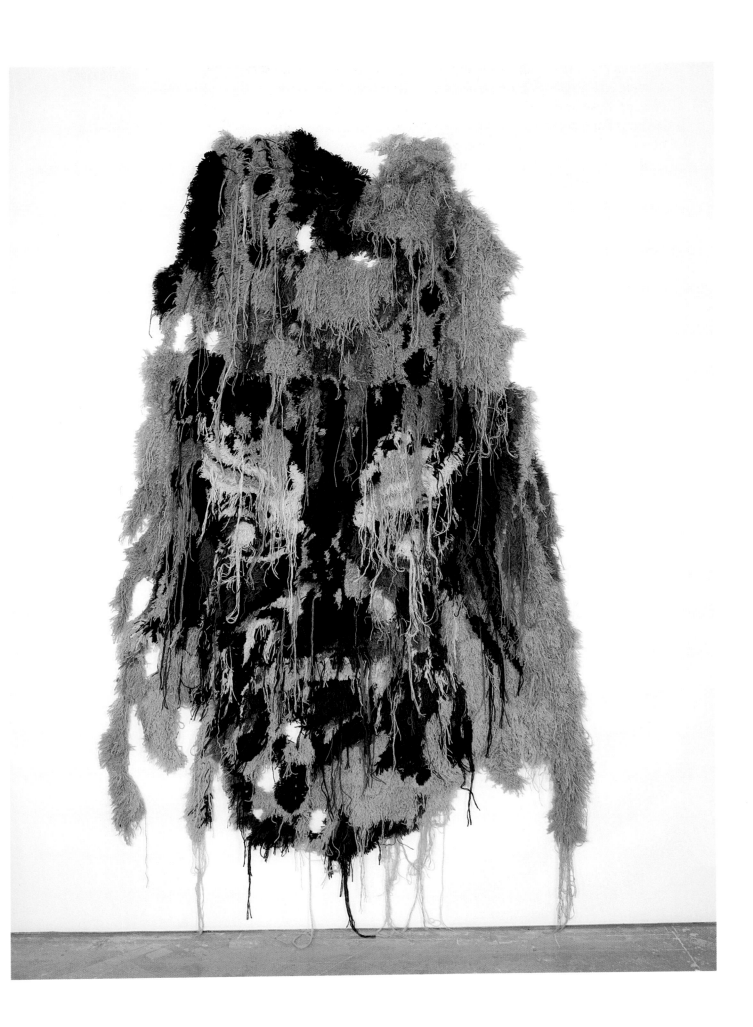

Mother George, 2015

23

Splitting Image, 2015
L.O.C.K., 2015

Preparatory drawing, 2015

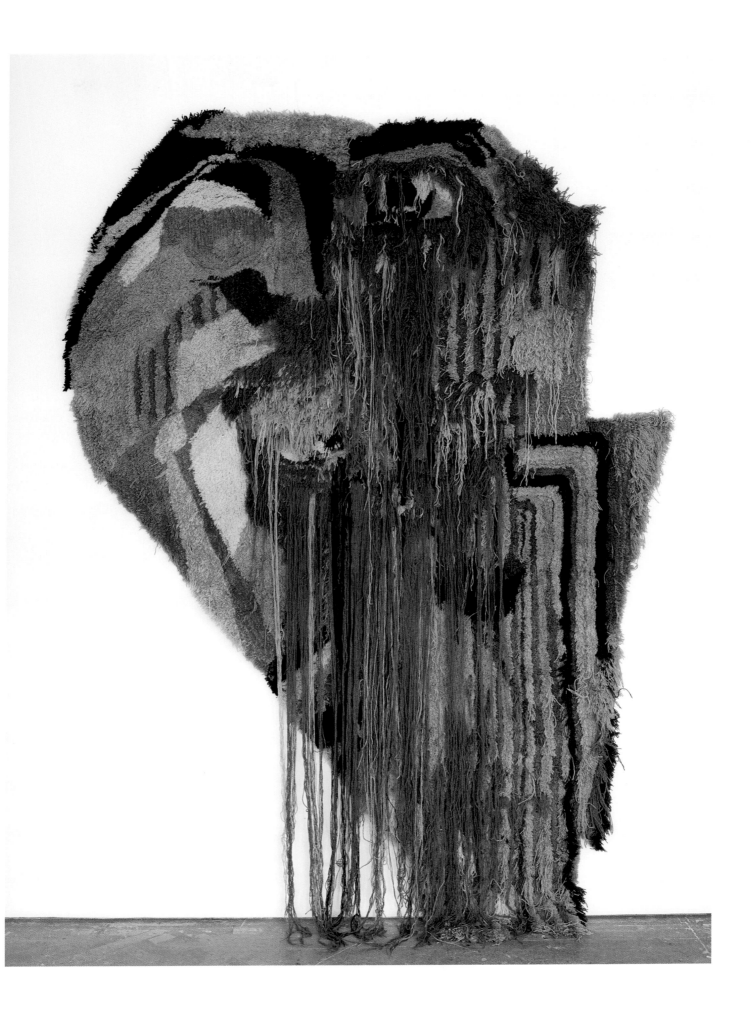

Todo Custo, 2015

25

John Akomfrah & Trevor Mathison

All That Is Solid Melts Into Air (2015) is concerned with transience
and the impossibility of capturing the unrecorded voice and the
undocumented past. The initial inspiration for the work was the
French director Alain Renais' film on the Nazi concentration camps,
Night and Fog (1955). These words were used by Hitler when he
ordered the disappearance of dissidents during the Third Reich
under cover of darkness. Using a web of texts, John Akomfrah
and Trevor Mathison construct a narrative about two fictional
characters who, like the father and son in Cormac McCarthy's
post-apocalyptic novel *The Road* (2006), try to make sense
of a world which they will leave without a trace.

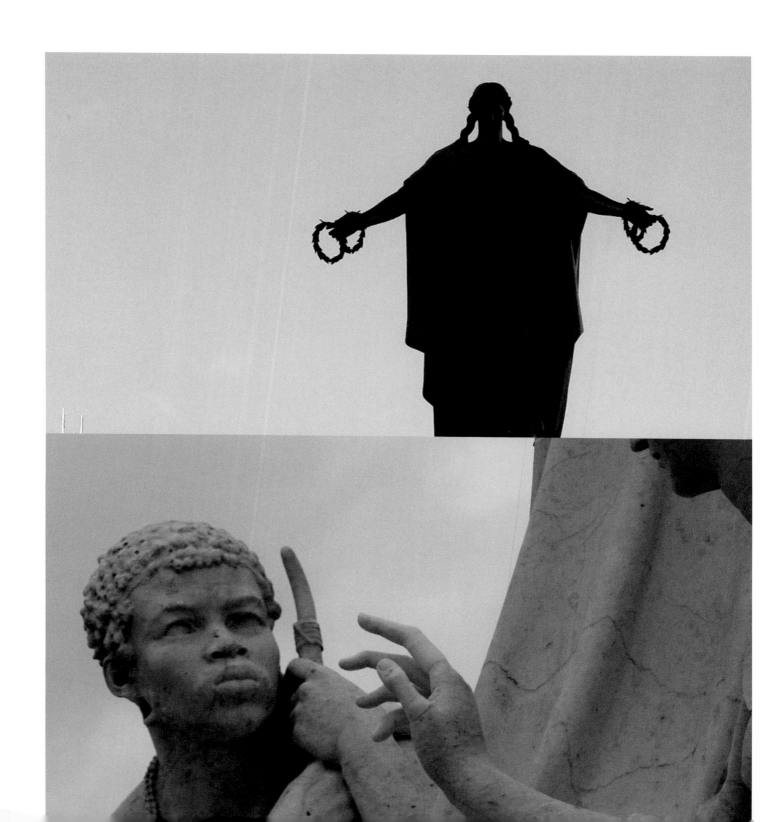

Aaron Angell

Aaron Angell's small-scale ceramic tableaux have an eclectic set of
references that include hobbyist cultures, psychedelic poetry and his
own ancestral history. To Angell, clay is a 'versatile and democratic'
sculptural medium that should be extracted from its association with
craft. His eerie reverse-glass paintings, *Peach – Portcullis* (2015) and
It is ten cloth yards in length (2014), were made by flicking paint onto
glass in a process of laborious accumulation.

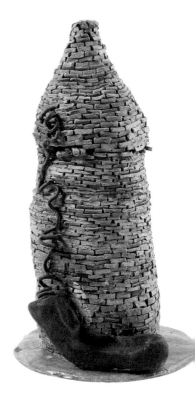

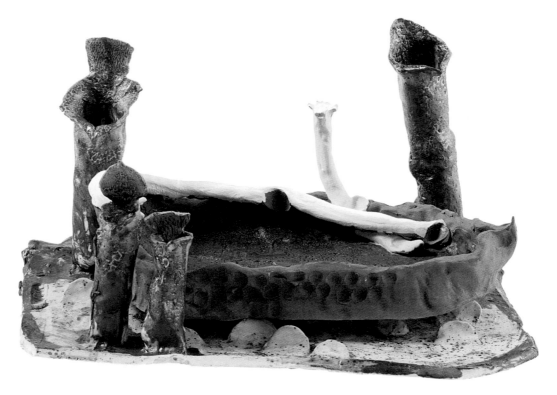

Dalmatian Spoon & Three Torcs, 2015

Bottle Kiln – Receiver, 2015

*Tortoise, Candle Holder
Variations (Nepenthes)*, 2015

Peach – Portcullis, 2015
(top, within installation view:
Studio Voltaire, London, 2015)

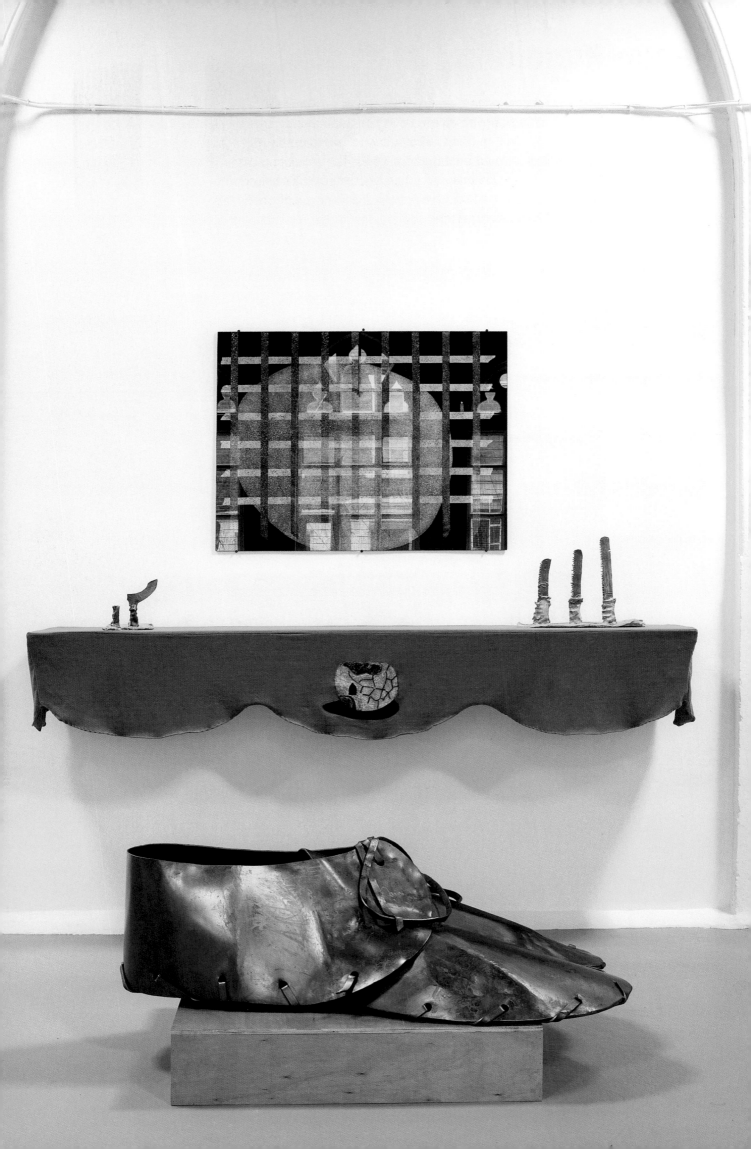

Pablo Bronstein

Pablo Bronstein's detailed architectural drawings are informed by stylistic, social and technical developments in European architecture. While previous works such as these have seen him examine the architecture of prisons, the postmodern buildings of central London or the machinery of the Industrial Revolution, the large-scale drawing he will produce for *British Art Show 8* examines the relationship between greenhouses – commonly constructed from glass and steel – and the birth of modern architecture.

Minton China Factory, 2015
(preparatory image)

Lowestoft Porcelain Factory, 2015
Worcester Porcelain Factory, 2014–15

Adam Broomberg & Oliver Chanarin

For *Every piece of dust on Freud's couch* (2015), Broomberg & Chanarin hired a police forensic team to scrutinise Sigmund Freud's iconic couch in the Freud Museum, gathering DNA samples, strands of hair and a multitude of dust particles left by human visitors, as well as traces of Freud's infamous early patients, Dora, the Wolf Man and Anna O. They have rendered the high-resolution radiographic quartz images (opposite page, top) as woven tapestries, mirroring the scale and texture of the original throw that covered the couch.

BET 7kV WD9mm SS47 30Pa x430 50µm
Persian Rug _HQ 0006 16 Jun 2015

Trace fibre from Freud's couch under crossed polars with Quartz wedge compensator (#2), 2015

Trace evidence 2, Freud's Qashqa'i rug, 2015

Trace evidence 2, Freud's Qashqa'i rug, 2015

BES 7kV WD9mm SS47 30Pa x170 100µm
Persian Rug _HQ 0003 16 Jun 2015

For *Dodo* (2014) Broomberg & Chanarin worked with an archaeological team to excavate a B-25 bomber, buried on site following the filming in 1970 of Joseph Heller's 1961 novel *Catch-22*. The discoveries from this dig are exhibited alongside a 'nature documentary' re-edited from previously unseen offcuts from *Catch-22*, showing the deserted coastline and wildlife of the Sea of Cortez as it appeared before the film crew arrived to transform the landscape. The disappearance of the plane and the landscape recalls the fate of the dodo, the first species known to have been made extinct as a result of human activity.

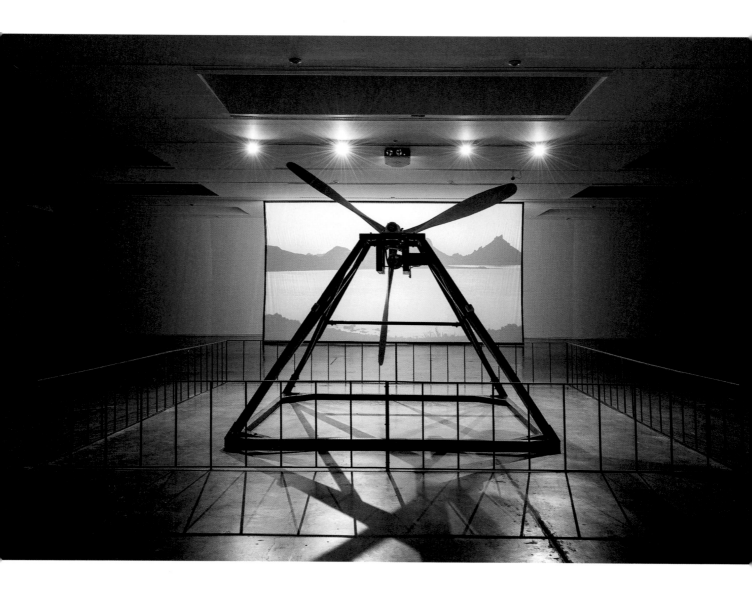

Dodo, 2014
(installation view: Jumex, Mexico City, 2014)

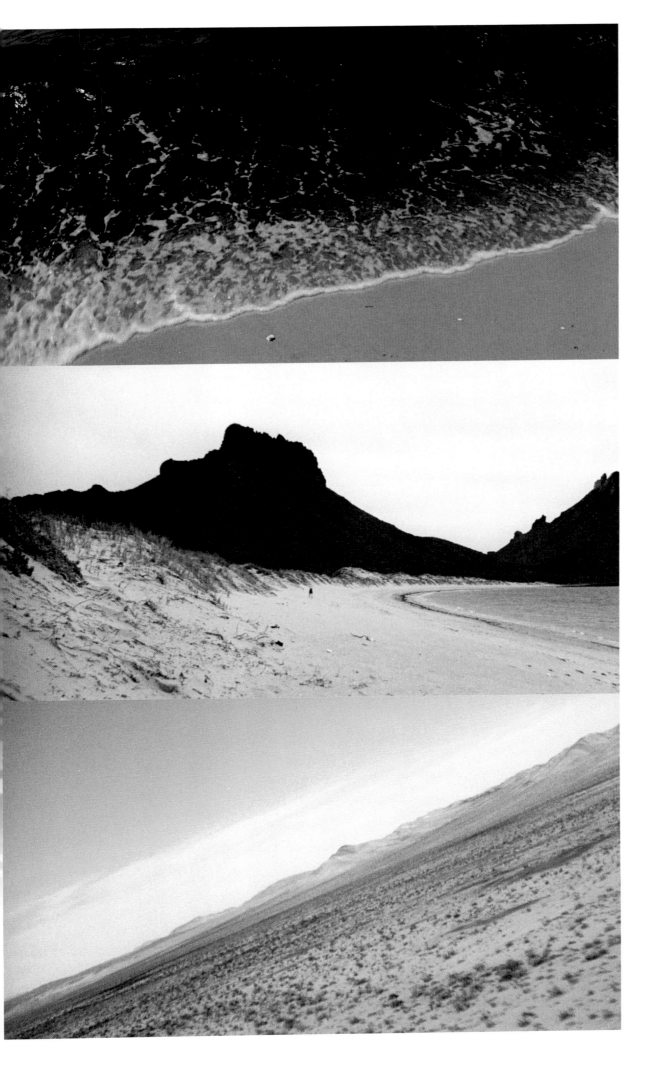

35 *Dodo*, 2014 (film stills)

Andrea Büttner

Andrea Büttner's *Images in Kant's Critique of the Power of Judgment* (2014) consists of 11 offset prints featuring a sequence of over 200 images chosen by the artist to accompany a new edition of Immanuel Kant's 1790 treatise *Critique of the Power of Judgment*. The selection, stemming from Büttner's close reading of the text, consists of images mentioned by Kant as he sets forth his famous theory of aesthetics. Many of the illustrations are drawn from books in Kant's personal library, while some of the more recent visual material was found on Wikimedia and Flickr.

Alexandre da Cunha

Alexandre da Cunha's sculptural objects show his interest in industrial production, making use of commonplace materials and everyday commodities, from cement to mop heads. Not only does the artist reuse the same type of material to create series of works, da Cunha's individual sculptures are also frequently made utilising several copies of the same item, repeated as if on a production line. Through employing domestic objects and disrupting their utilitarian nature, the artist draws attention to the subjects of labour and value, both in art and the wider world.

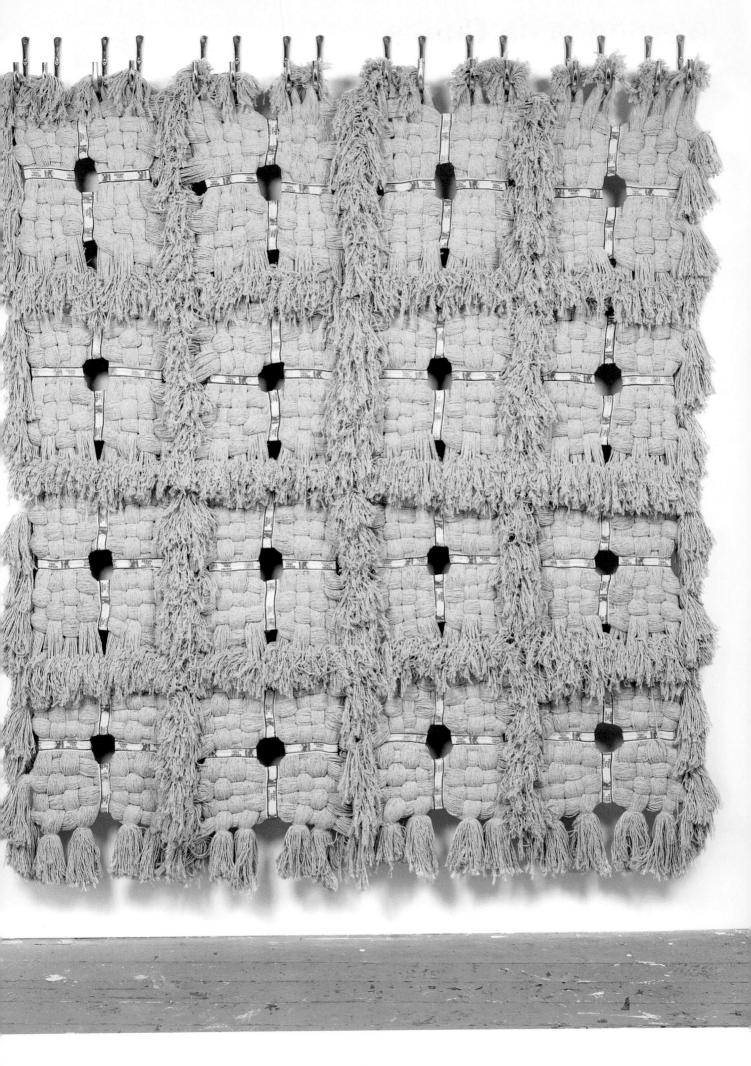

Fatigue (diagram I), 2014 39 *Kentucky, 2010*

Nicolas Deshayes

"My direct involvement is often to do with surface. I intervene once rigid structures have been welded or fabricated to my specifications and apply a skin onto the work. On other occasions the skin itself forms the whole structure, for instance in vacuum forming or hollow ceramic extrusion."

From 'Roundtable on Production', pp.54-55

Floor (four works): *Becoming Soil,* 2015

Wall (two works): *Vein Section (or a cave painting),* 2015

(installation view: Fridericianum, Kassel, Germany, 2015)

Preparatory sketches, 2015
Production images, 2015

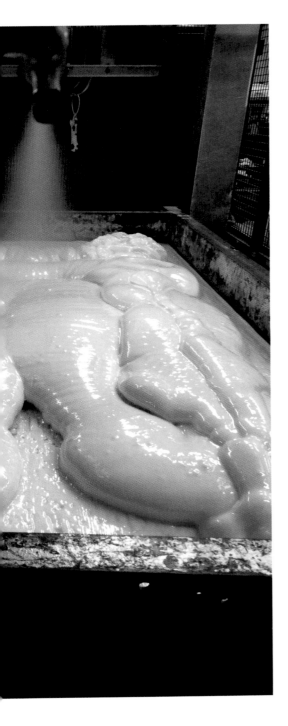

Pipe Study, 2014
Pipe Study, 2014

Benedict Drew

Benedict Drew's new installation *Sequencer* (2015) is a composite object formed of drum machines, videos and a singing voice. Working within the realms of moving image, sound and sculpture, this new work will present, in the words of the artist, 'an environment dripping with the false promise of desire and seduction conjured by the mediated image of the lens, the screen and the loudspeaker'.

Sequencer, 2015 (production image)

P. L. Doclus, Coloured drawing of large
sea snail, soft parts protruding, showing
snout, eyestalks and foot with claw-shaped
operculum, 1844

45

Close-up of Mud Pot,
West Thumb Geyser Basin, 1971

Mud Pot, Norris Geyser Basin, 1967

Simon Fujiwara

To create the works in his series *Fabulous Beasts* (2015),
Simon Fujiwara purchases European vintage fur coats, once
luxury commodities, and shaves them, exposing the patchwork
of animal skins beneath the uniform surfaces. Stretched to
appear as canvases or primitive hides, the abstract surfaces
speak of their own highly laborious production methods.

Heinrich Lomer's fur emporium
in Leipzig, 1905

Fabulous Beasts (Deep Blue Mink), 2015

Fabulous Beasts (Chequered Fox), 2015

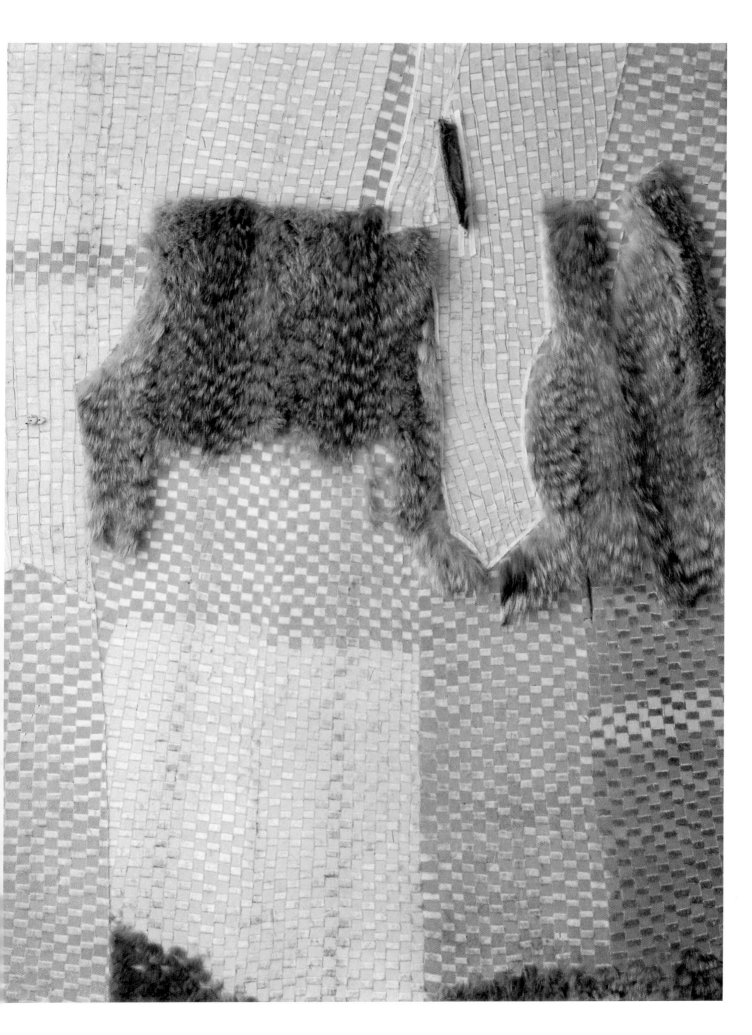

47

Fujiwara's film, *Hello* (2015), contrasts two protagonists – Maria, a poor rubbish-picker from Mexico and Max, a young Berlin-based CGI programmer – whose lives have both been radically altered through socio-economic shifts. The overlapping interviews are animated, edited and controlled by a floating, computer-generated severed hand produced by Max who was born with no arms.

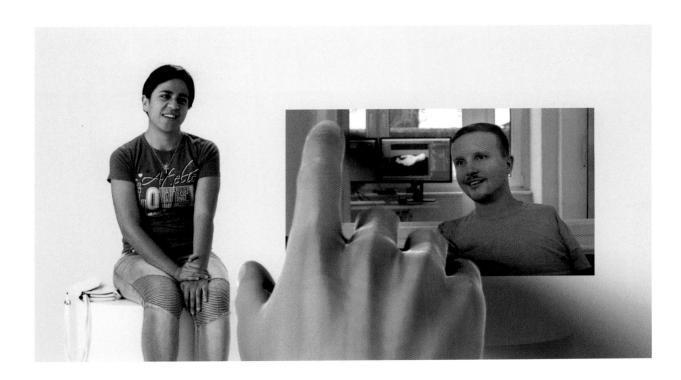

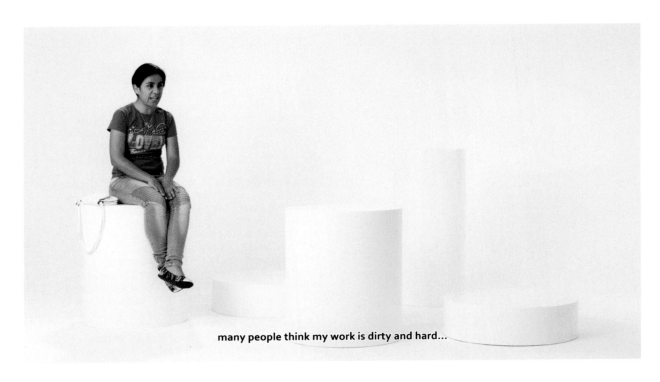

many people think my work is dirty and hard...

Martino Gamper

Martino Gamper's *Post Forma* is a series of peripatetic workshops
that asks the public to re-evaluate forgotten and damaged objects.
A number of stands are manned by skilled craftspeople drawn from
the local area, with each cart championing a particular specialism:
book-binding, weaving, shoe-cobbling and chair-caning. Broken
items brought to these workshops are not only repaired but
enhanced by a signature flourish chosen by the artist, to transform
the repaired object into a renewed and unique piece of design.

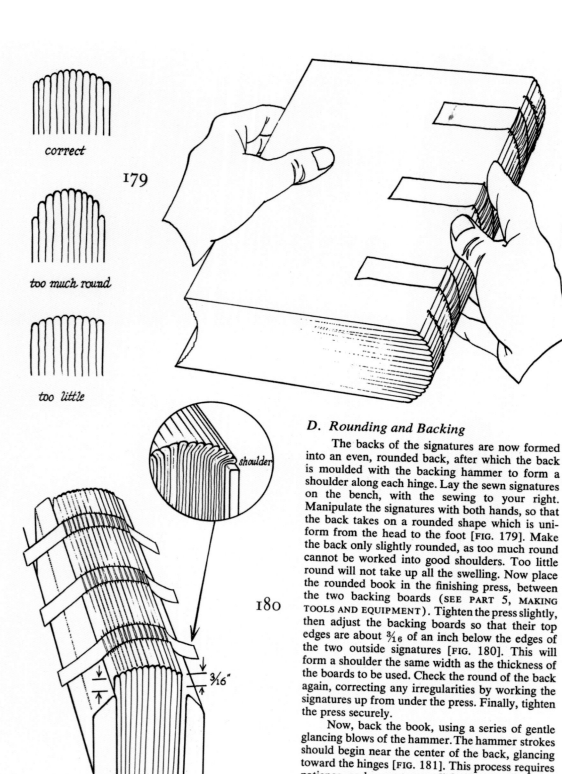

correct

179

too much round

too little

shoulder

180

3⁄16"

D. Rounding and Backing

The backs of the signatures are now formed
into an even, rounded back, after which the back
is moulded with the backing hammer to form a
shoulder along each hinge. Lay the sewn signatures
on the bench, with the sewing to your right.
Manipulate the signatures with both hands, so that
the back takes on a rounded shape which is uni-
form from the head to the foot [FIG. 179]. Make
the back only slightly rounded, as too much round
cannot be worked into good shoulders. Too little
round will not take up all the swelling. Now place
the rounded book in the finishing press, between
the two backing boards (SEE PART 5, MAKING
TOOLS AND EQUIPMENT). Tighten the press slightly,
then adjust the backing boards so that their top
edges are about 3⁄16 of an inch below the edges of
the two outside signatures [FIG. 180]. This will
form a shoulder the same width as the thickness of
the boards to be used. Check the round of the back
again, correcting any irregularities by working the
signatures up from under the press. Finally, tighten
the press securely.

Now, back the book, using a series of gentle
glancing blows of the hammer. The hammer strokes
should begin near the center of the back, glancing
toward the hinges [FIG. 181]. This process requires
patience, and a great many light blows to bend the
signatures gradually down onto the beveled edges
of the backing boards. The signatures next to the

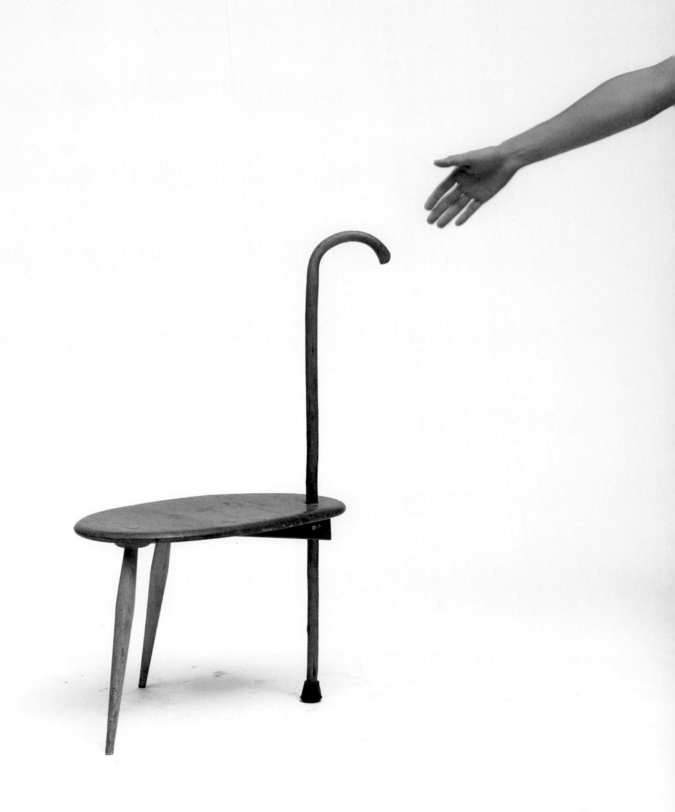

From Aldren A. Watson, *Hand Bookbinding:*
A Manual of Instructions, 1963

Hands On, 2006 (from the series
100 Chairs in 100 Days, 2005-07)

Andrea Büttner
Nicolas Deshayes
Martino Gamper
Ryan Gander
Charlotte Prodger

In conversation with François Quintin

Roundtable on Production

François Quintin: The word 'production' was first used within the context of the construction of the great cathedrals. It designated the arts practices and the rules that artists needed to incorporate in order to fit the overall project. Its industrial meaning is quite recent, in relation to the history of humanity. But production is still a 'suitcase word' (as we say in French) that has a different meaning in each discipline, for each practice, even for each artist. In art, it loosely revolves around ideas like experimentation, conception, fabrication, reproduction, etc. Besides, the economy of contemporary art obliges most artists to become their own project managers, which is rarely the case in cinema, fashion or architecture, for instance. However, art has been developing in directions that are not so far from those other disciplines.

Let's begin to approach this confusing concept by starting with your individual practices. How would you describe what you do and how you go about doing it? Where do your ideas come from and how do they develop into new works or projects? Does it start with research or by experimenting in the studio?

Andrea Büttner: I like to make different things. I do different things and am involved in different processes: in the studio, while walking, in workshops, reading and talking with friends, looking at things.

My work involves academic research (like for the project in *British Art Show 8*), glass painting in the studio, glass painting in a glass workshop, carving (preferably outside), printmaking, strolling in the city and drawing (at home and in the streets), gathering moss, emailing with academics and artists' estates. I love to work with workshops, with foundries, printmakers and glass-painters. Often I develop ideas or images while working in those environments.

I don't think I 'develop' a new project. There is a more passive aspect to making work; a 'new project' develops in me. I often wonder how I can create good conditions for this development (like a farmer, creating good conditions for the growth of plants), but am still unsure what these 'good' or productive attitudes or activities are while I'm waiting.

I should add that I don't like the notion of the 'new project'. It sounds like a demand of the industry and the language of academic marketing and fundraising. I like to show old and new works in new relationships in my exhibitions. And they are all part of the same process and search.

'Research' always sounds a bit validating and there is a strange relationship to shopping, in terms of choosing content. Selecting. Gathering. I try to keep space and time for dreaming and '*Einbildungskraft*' [imagination].

Ryan Gander: I have a real mistrust of 'genius pieces'. In fact I mistrust most artists who make 'a few works all of which are good', also. Anyone can make a good artwork once or twice a year and keep boshing them out.

53

But really good artists make a lot of crap and throw away a lot too, and that's the way it should be. Isn't it the mistakes we learn more from? The pursuit of art should be about development and education, pushing things forwards, whatever it ends up looking like. I have a great list somewhere of all the artworks I'm terribly ashamed of. I keep adding to it and I think I would worry more if I didn't.

I get really excited about the idea of practice, looking at an artist's entire life, a 70-year span, and studying the twists and turns and progression. Trajectory is more interesting than any singular artwork. It's a long game and it has to be about pioneering and exploration or it's not on the map for me. I guess I'm saying this because I work in an accumulative way. Sometimes I feel like a kid with Asperger's who collects compulsively – not just physical stuff, but words and pictures and descriptions of situations, interviews with people, perfume swatches, photos of ladders and Ikea tables, and of course physical stuff too like stones and dinner seating cards. But that's the only way I know of practising – by hoarding catalytic points.

Ideas take a year or two to filter through the cognitive digestive tract, so I've never dared to stop researching for almost a quarter of a decade. The generation of material and these phenomenological starting points is most of what I do. People work in different ways. The mastering of a practice is an obtainable goal, but only if you know what your practice is. Do you see what I mean? My job spec changes weekly; there's no way you can really have much of a logical methodology, in that you just have to keep running.

Charlotte Prodger: There are narratives and narrative fragments (anecdotes, found texts and my own writing) that circulate in my thinking, sometimes for years, before I use them. And there's a continual process of filtering them out or distilling them. Sometimes it happens that things become less interesting over time and naturally fall away. Often things come to the foreground by talking with friends.

And there are forms, physical forms or formal motifs, that hang around for me in the same way. Sometimes it's, for want of a better word, 'intuitive'. For example, I use holes a lot in my work and am not exactly sure why. This started out as a compulsion to punch holes in materials and the enjoyment of the neat formal rupture of 'here's a presence, now there's an absence'. The visual language of typography and graphics is also always there for me as a way for material to shape content. The grid is always present for me in some way, as a formal constraint for subjective narrative content, which is often messy and slippery, jumping around in time and space.

These days I look a lot at building sites, agricultural equipment and large-scale maritime equipment and technology. Not necessarily going out of my way to research it, rather gleaning it by default, while travelling through the countryside, or on a ferry to the Scottish islands, or walking through the city. Those functional materials influence the anthropomorphic display structures I design for holding audiovisual technology.

These two strands I've described – the form and the content – evolve more or less in relation to each other. Whether one leads the other varies from work to work.

Nicolas Deshayes: I tend to work with industrial processes and materials that relate very directly to the body in a world outside of art. These materials can be antiseptic or ergonomic or used in civic situations, where the flow of bodies and their by-products have to be controlled and directed.

The production lines in the factories I work with house transient archives of incongruous objects and parts, ranging in scale and corporeal use-value to incorporate things like Pizza Hut baking trays, coffee cup lids, caravan mouldings, Tube station cladding, wave turbine components and sewage pipelines. All these things then become the context for the objects I produce there, even though they might bear little resemblance.

My direct involvement on site is often to do with surface. I intervene once rigid structures have been welded or fabricated to my specifications

and apply a skin onto the work. On other occasions the skin itself forms the whole structure, for instance in vacuum-forming or hollow ceramic extrusion.

I work with manufacturers who happily give me access and basic training on how to use their processes, and through my various projects I have developed an anti-skillset that relishes in production mistakes and inconsistencies, so that generally I produce a surface that looks toxic or contaminated and therefore closer to something corporeal.

Martino Gamper: My approach is very much driven by the direct creative process (spontaneous making process); in many of my works I realise the projects myself or in close collaboration with artisans. This is very different to many designers or the way designers traditionally worked, especially since most Italian designers of the last century were trained as architects and draughtsmen.

By creating one-off pieces and commissions I work with industries that need to be fed designs and drawings, but it can be creative in a very personal and individual way in my studio. Creative freedom, research and personal expression have always been very important parts of my practice. I've worked on many self-initiated projects and collaborations over the years, and see my studio as a very plural and creatively diverse place where the artistic design process is at the centre.

I don't really approach the unique versus the mass-produced any differently. In the unique and self-initiated, as in the mass-produced, there is a brief or limitation, a functional constraint, but the initial ideas come from the same creative process. In the case of a chair, this is very playful and mostly in three dimensions. The two processes also influence and nurture one another: industry uses interesting manufacturing processes that the artisanal workshop can't reproduce, and vice versa.

FQ: Although you have all been working for at least a decade, some of you talk about the beginning of a project as a major enigma. Andrea

describes a passive process of creation, of 'Einbildungskraft', and says that the project develops in her, while Charlotte defines herself as a glanneur [gleaner] by default. She also talks about 'filtering narratives', and I very much like the reference to holes she makes in materials as creating an absence. Ryan is talking about the accumulative aspect of his work, and a long-term process of filtering things through a cognitive digestive tract. Nicolas and Martino speak about a more direct relationship to materiality. Materials, processes and relationships with others (craftsmen, companies, new material, re-use of material) are the starting points of a project.

Could any of you describe a specific example of a 'moment of decision' in a project of yours that is emblematic of how an idea became reality?

RG: I think perhaps the works (specifically the wallpapers) record the moment of decision. There is of course some premeditation, but essentially the subject of the work is the making of the work; the process seems to unravel and display itself automatically. This is more self-spectatorial than self-referential. It's very hard to identify moments of decision and revelation for me; there are no significant signs it is happening. I often wish the clouds would part and a ray of sun would shine down upon me and the angels would begin to sing, so I could identify it was happening, but it really doesn't work like that. It's more of a mesh of learned behaviour that has become instinct and subconscious from the previous million decisions made through making thousands of previous works.

FQ: I've always been intrigued by this coincidence: Claude Lévi-Strauss wrote in La pensée sauvage (1962) about the 'bricoleur'. He describes his 'retrospective practice', always returning to the elements he has collected to create again and again new inventories of possibilities. Around the same time, the creators of the TV series Star Trek were imagining a society without tools, where everybody is dressed in fitted pyjamas, hanging around unknown planets and using retro-futuristic interstellar smartphones. Already back then it triggered

the current fantasies of omnipotence and omnipresence by absence of material and tools.

Would any of you say that recent technologies have changed your way of working or thinking? Do they alter your relationship to materials or processes? Are there any works you would have made differently today than a few years ago?

AB: The biggest change in terms of recent technologies is the smartphone. The smartphone has introduced the easy, at-hand Internet into the studio and thus issues of productiveness and unproductiveness, ways of drifting, a lack of emptiness and boredom. The smartphone changed my thinking about my use of the knife and made me more interested in the cut again, and in woodcutting – the cut as a gesture that is opposite to the swipe. The cut is a decision that can only be carried out once, that has an effect on the surface, that requires strength and concentration. It is not reversible – as a movement of the hand can go wrong – which makes it more full or exciting.

MG: Sometimes I start working digitally (also controlled by hand) and this then gets translated and transformed into a physical and hand-workable object. Or the opposite happens, where I create something by hand using hand tools and then transform it with digital tools. Both are tools for me.

RG: Recent technologies have changed the way I work by insisting that I slow down technology and embrace material and physical tools. I guess this path is a knee-jerk reaction that more and more people are following as an opposition to new technology. The 'post-net' era was very short lived, and quite rightly so, as most of the work being produced in that genre was empty and simply mimetic aesthetics. In addition 'post-net' as a theme never seemed to have a lot of scope for exploration, a couple of positions and perspectives being voiced by thousands and thousands of young artists doesn't really make for great spectatorial opportunity.

A slowness is most definitely upon us, as a counterpoint to the speed we saw in the previous few years. Slow culture surrounds us as much outside the language of art-making.

Half of the buildings in Soho have been painted black or dark grey making us feel as though we are walking through Victorian London; the longer the coffee takes to make the better; we have massive trends in ceramics, leatherwear, artisan breads, foraging, allotments, knitting, the handmade, the home-brewed. And beards are a-plenty. Now only longevity towards materiality in relation to tools and clothes is acceptable.

Last New Year saw a frenzy of people downing devices in a social media amnesty. In general all this makes me pleased, the knock-on effect possibly being that people spend more time with singular works, delving deeper. But part of me worries that from this slowness can only come a counter-effect of more speed. The main problem with technology and speed is that people drop what they are looking at without fully exploring its potential, in order to grab the next new thing so that they don't feel like they're missing out, and therefore experience becomes superficial. It feels as though a lot of art is made by rooting through the compact disk bargain bin of life, looking for the obscure EP that no one else has heard, without questioning the reason why the compact disk was in that bin in the first place. It's a tune we just might not want to dance to.

ND: I often strive for more freedom in the work I make, and sometimes I wonder if limited technological means might allow that to happen more easily. That said, I enjoy a hands-on connection to how objects are manufactured across specialist fields. The industrial does not necessarily stand for dehumanised making; mechanical actions are still controlled by hand and brain through an acute and sensitive understanding of materials. I have found that the varying processes I use are often subject to extreme shifts in temperature, and I'm attracted to the sensuality of these slipping states. By default this sensuality in the making process has become one of the criteria I look for when thinking about new technologies to work with.

FQ: In French, the word 'atelier' has both the meaning of 'workshop' as well as 'studio', although they seem to be in contradiction with one another. The studio is synonymous

with introspection, fundamental research or creative retreat, whereas the workshop is a place of fabrication that implies collective effort and complementary skills. How do you consider your space of work? What form of life is growing there every day? What would be one concrete aspect of your studio that is distinctively relevant to your practice?

AB: The most relevant aspect of my studio is the way to the studio, walking there and all the other people on the street begging, shopping, eating, playing music, minding their own business, looking beautiful. I love especially one specific street in Frankfurt, a very dull and generic pedestrian shopping street called the Zeil (which means 'row' but also 'line', like in a poem) where everything happens. I try to draw each evening some things that I loved seeing.

ND: I have a yam sitting on my windowsill at the studio that I bought on Ridley Road Market three years ago now; remarkably it still hasn't decomposed and has become a kind of mascot.

My studio is a place where I do things like drawing and casting and assembling parts that I make elsewhere. It's also a place where I can set up an artwork and look at it before it goes off on its travels.

In periods between shows I tend to do lots of watercolour sketches as a kind of palate-cleansing exercise. Some of these germinate into concrete projects while others just exist as outlets for procrastination. I like drawing because it has an immediacy that supersedes any of the other processes I use.

My other studios are the factories that I work in, but these are places of physical endurance rather than slow thinking. Areas of high-volume production that I navigate like a little but productive mouse to ensure I'm not in the way. It's a place that generates lots of material discoveries and I spy things and have conversations there that inspire new ideas for return visits.

CP: For me, the beginnings of how works first come into being are generally not in the studio. It's such a slow process; a slipstream of cross-associating experiences that happen at various points in time and space, when I'm out in the world going about my life: walking in the countryside, sitting on a train seeing fragmented situations passing in sequential rhythms; walking in the city with headphones on, listening to an hour-long mix that frames everything like a mood board; talking with friends; looking at clothes; reading groups; screenings; smoking weed alone. There isn't a beginning and end to making a work and 'research' for me isn't a distinct quantifiable period – it's an accumulative, shifting process that is slippery in terms of time. Andrea's wariness of the idea of research as a definitive process and of the 'new project' as a demand of the industry really resonated with me.

The studio is where I start the process of the active 'making', rather than the place where the ideas begin. For me, movement is conducive to the beginning of ideas. The rhythm of being on trains or walking in open spaces for sustained periods seems to activate something in my brain that sets ideas in motion. I stop and write notes on my phone.

I have long periods of not being in the studio because of the administrative demands of being an artist. I try not to bring too much admin into my studio, to keep it as a clear space without too many voices coming at me. The studio is also distinct from the domestic, which is very important to me. There is a lack of visual noise and what's in there is, as much as possible, physically arranged on my own terms. That's a precious thing and in that respect I really value it as a space to retreat to for concentration or just hanging out, like a garden shed. I value the silence of the studio. It's where I write, do my technical drawings and get to know equipment. Wall space is also important – that blankness. I use large sheets of paper to map out ideas, and relationships between language and form. These are scores for my installations. That's the most consistent visual content in my studio: the pieces of paper on the walls with the mapping out of ideas (writing) and the drawings for fabrication. They're constantly being replaced and reworked but they're always there.

When production begins it demands a sustained, industrious period of making which is definitely concentrated around the studio, with that being my sole focus for several weeks at a time. By its nature that's a less discursive and more dynamic mode of working: troubleshooting materials and designs, working with fabricators, coordinating logistics. So people come in and out of the studio during those periods, which they don't so much at other times. Those periods do have a beginning and an end, defined by the schedule of shows.

MG: My studio is a space I share with my wife, the artist Francis Upritchard. It's a mix between a kitchen and a big generous table to eat, think and read at and share ideas. It's also a workshop where things get made so that the thinking and the making live side by side. It's a very social space with lunch being cooked and shared with whoever happens to be in the studio or dropping by that day.

FQ: Could you each give five words that you use in your practice to describe a step in the production process (i.e. prototype, sketch, maquette, rushes, ozalids etc.)?

AB: Reading, looking, thinking, sketching, walking, drawing, relief board / printing plate, carving, printing, proofing, editioning, firing glass, choosing / mixing colours, signing.

RG: Possible, catalytic, hamster (derived from 'Hamstern' in German meaning 'to hoard'), collection, list. It also works as a sentence: possible catalytic hamster collection list. But doesn't work as a logical anagram: PCHCL.

ND: Dipping, baking, melting, sucking, cooling.

CP: Conversations, rushes, paragraphs, technical drawings, RAL chart.

MG: Three-dimensional sketching, hoarding, mending, improvising, spontaneity, gingery.

Ryan Gander

The way things collide (2014), *Pushed into the corner by the logic of
my own making* (2012) and *The cold was as three-dimensional as the
studio* (2015) respond to the still life through photography, text
and sculpture. In the latter – a 1:1 photographic reproduction of
a scene from Gander's studio – a piece of fabric is caught mid-fall,
while ideas for unrealised works line the walls. The film A *flawed and
wounded man bleeding frames onto a page* (2014) records an audio
performance of a children's book written by the artist, exploring
architect Ernö Goldfinger's relationship to Trellick Tower,
a 31-storey block of flats in West London.

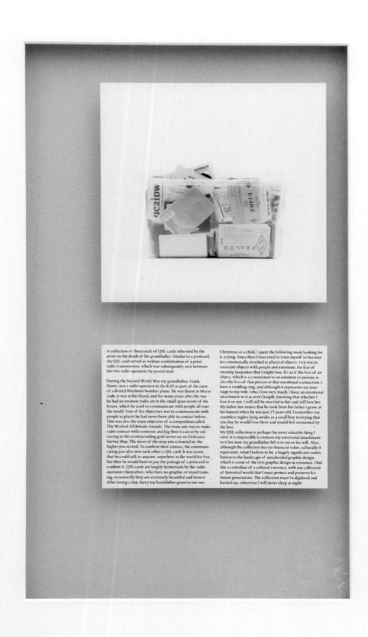

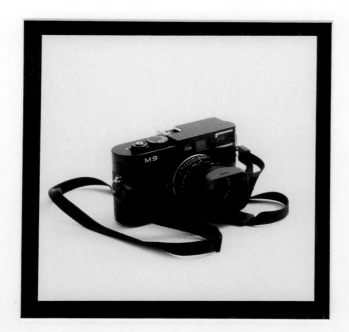

*Pushed into a corner by the logic
of my own making – Leica M9, 2012*

*Pushed into a corner by the logic
of my own making – QSL Collection, 2012*

he advert

Miming cricket
baseball with
umbrella

Design own
amphitheatre

Look at how teamwork
works and bee colonies, and
sects and the stratification
systems in them and
positions in football team

Thornet sledge

A really well made architectural
model of the Amazon HQ with a
big wall paper of a girl lying in a
reclined pose. the logo of amazon
in should be abstracted but
familiar and uncanny without
saying 'amazon'

Crushed up
receipts carpet
popcorn carpet

Cinema by type
sign with
changeable letters

serving

A wor
n

tory of
se the

Tiny beers
Maastricht rack

Body language
illustrations?

A work from a novel
where software finds the
most popular or least
popular words are erased

Self-portrait
with dressing
on face

es along wall
acks of chairs
en rubbing in
waiting room

Rear lights on a
alfa romeo

Lyric: Start each line with
because : and reference
the copy editors name
from the copywriter book
who invented tat device.

Lyric: Ballsy
arrogant work,
ballsy arrogant
people

A work from a novel
where all words apart
from two words are
erased

White chalk
marker in
tinted glass.

of long

Intermission
with music in
ghandi

Lyric: I don't know
if i have got the
guts to go on

ging in
ds

s
t

One song
work

Poster work printed
matter the page form
ampersand that is
concrete poetry

World's fair
playground

lettering

Artificial staircase to a door
behind which is cutterheld (you
cant go up it - the engineering
of it means it appears to float,
but in fact is very lightweight
and is supported by the base
of the door

Hermes
fictional works

Pe
mu

Jazz band
playing in the
gallery

Find origami
doll template

Public phone
ringing

ing
e music

A giant hanging sound
system with a mini
jack hanging from it
down to a reachable
height

Sculptural recess
from around London
with the sculptures
removed

A series
physical
into from
but this w
changes.

Hundreds of
staples in wall

Vinyl on window to
make a football
sized peep hole

Castelli blank
check

me in blue
eadphone
om
angles

Transparent cavity walls on
either side which contain pages
torn from novels that mention
subject and its history. Fans in
the bases that provide a snow
storm of mixed narrative

A glass walled
complaints dept
suspended in the
air

A seri
boxes,
inacces

Sculpture
ergonomic in
neon

Degas kneeling
holding up cube to
light toy plinth in
hand

Porcelain collar
meet nze
t

c for
mer
on

Origami
intellectuals

Plaster reliefs

Letters
on Smiti
stationa

lit between
frames

Design caps
hotel

sket ball
me with only
referees

of a

Blobby sculpture
from mould for
bronze cast

Full sized
Aston

Crushing t
transient
space.

d
son

Put front
sticker on
sculpture

un
er

Slit between
two frames

B

crings in space
to divide space

Collide:Scallop,
meet tool
trolley

s
b

Plates set into a
wall pre history
self portrait

Yellows
flavour

Black
curtain

Massive out of focus
photocopy of black and
white thermal images of
artists in studios on neon
yellow paper

An animal
made of
vynamold

Padded leather
ar

La haine
Fictional works

Collide: The nose
of Aphrodite of
Milos, meet
Macbook Air

Indian nec

phone

CYOA book as
a publication

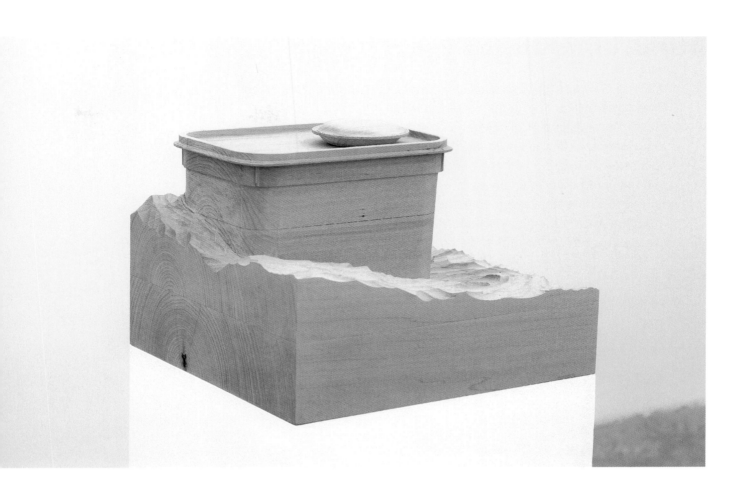

*The way things collide (Draughtsman's
paper weight, meet ice cream tub)*, 2014

*The cold was as three-dimensional
as the studio*, 2015

*A flawed and wounded man bleeding frames
onto a page*, 2014 (production image)

Melanie Gilligan

Melanie Gilligan's *The Common Sense* (2014–15) is a video installation that takes the form of a multi-episode drama set in a dystopian near-future. The plot of Gilligan's fragmented drama centres on a wearable device known as 'the Patch'. This device, a radical extension of existing technologies such as the smartphone, enables emotions to be communicated directly from person to person. Intended to create a more empathetic society, the Patch has instead resulted in an exploitative economy of emotions, where subjective experience can be bought and sold.

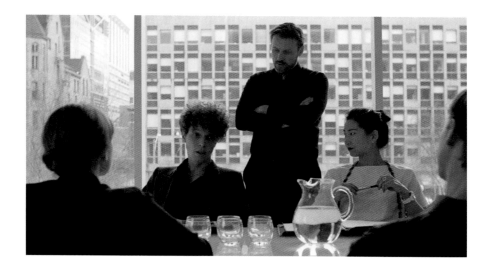

The Common Sense, 2014–15 (film stills)

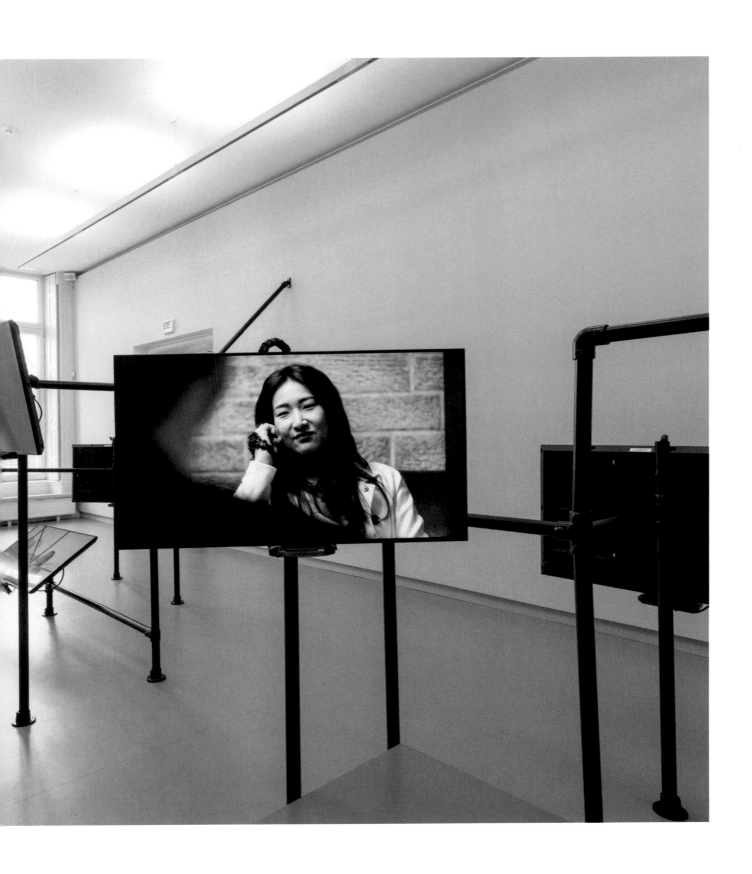

The Common Sense, 2014–15
(installation view: de Appel arts centre,
Amsterdam, 2015)

65

Anthea Hamilton

Anthea Hamilton's network of freestanding sculptures – which
make use of images from her previous works, including a reclining
Karl Lagerfeld – is a functioning ant farm. Over the duration of
the exhibition, the ants move through complex interconnecting
tunnels within the Perspex structures.

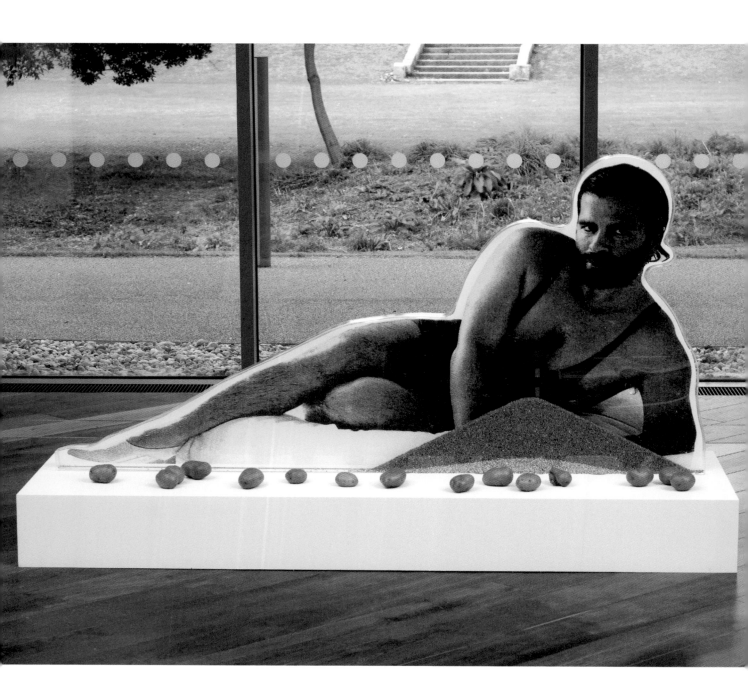

Karl Lagerfeld Bean Counter, 2012

Manarch (Pasta), 2009

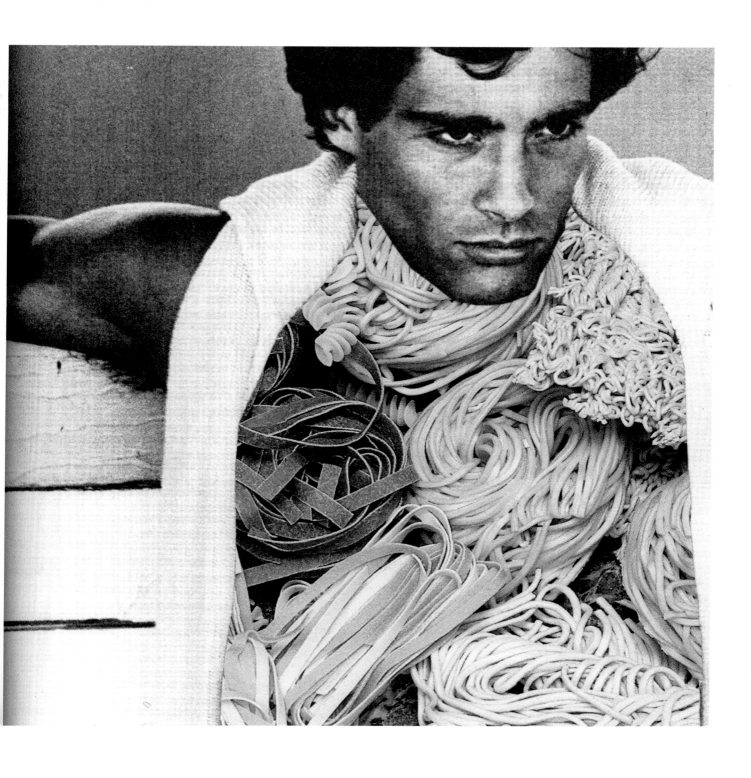

Will Holder

Typographer Will Holder is concerned with the organisation of language around artworks, where voices from various disciplines are mediated to provide meaning and access to art objects. Together with each venue's staff, Holder has selected a work from their collections made by a female artist. In four stages, he will 'draw a comparative lineage between Boris Arvatov's notions of the production of objects in the essay "Everyday Life and the Culture of the Thing" (1924) and a contemporary production of language'. For British Art Show 8 at Leeds Art Gallery, Marlow Moss' Spatial Construction in Steel (1956–58) has been selected. The sculpture will be displayed with a hand-drawn wall text produced by Holder while he gives a public talk.

Marlow Moss
Spatial Construction in Steel, 1956-58

[Hum] There is a world of communication which is not dependent on words. This is the world in which the artist operates, and for him words can be dangerous unless they are examined in the light of the work. The communication is in the work and words are no substitute for this. However, there is an idea that it is a duty on the part of the artist to offer up explanations of his work to the élite who are in control of its interpretation and promotion, and the necessity of such an élite being as well-informed as possible is certain. Mary Martin, 1968, 2015

M M M M M

M M M M M

M M M M M

M M M M M

MARY

69

Alan Kane

Alan Kane has contributed a number of functional elements to 'service' *British Art Show 8*, including a range of gallery seating and a doormat of the kind commonly found in homes. Kane's doormats attempt to collapse the distance between domestic and institutional settings, their messages of welcome perhaps encouraging the new audiences that these institutions seek. His benches, made from gravestones and powder-coated steel, draw on and advance the tradition of the memento mori by emphatically inviting the viewer to become a participant in the work.

The But., 2015 (preparatory sketches)

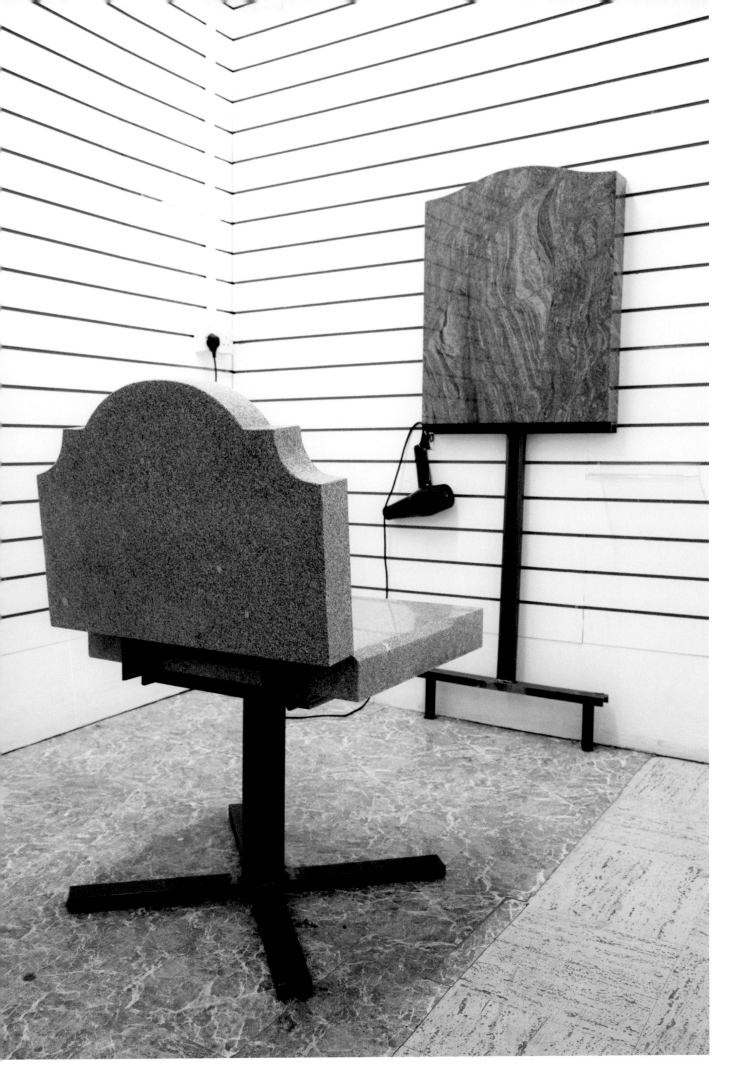

Vanity Suite ∕ Sorry, 2015
(installation view: DKUK, London, 2015)

71

Mikhail Karikis

In *Children of Unquiet* (2013–14), Mikhail Karikis explores the sociopolitical and industrial history of Larderello, Italy, the site of the world's first geothermal power station. Technological developments in the late 1970s made many of the plant's workers redundant and resulted in the abandonment of the villages built to house them. In Karikis' film, local children reanimate one of these silenced villages through play, and recreate the noises – the hiss of steam from the geysers, the roar of the factory's pipes – of the volcanic landscape that they grew up in.

Children of Unquiet, 2013–14
(production image)

73 *Children of Unquiet*, 2013–14 (film stills)

Linder

Daughter of the Mantic Stain by Linder

*The restless child who cries out to the teacher, 'What shall I do?';
the inhibited patient who gazes with equal blankness at the paper before
him and the art therapist's face: indeed, all who find the actual beginning
of a work of art a difficulty, may be assisted by automatism.*

So begins an essay written in 1952, two years before I was
born, by the surrealist artist Ithell Colquhoun. The title of the
essay is 'Children of the Mantic Stain' and for the last few years
this text has been my creative pole star. The first draft of the
essay, written in 1949, was titled 'The Mantic Stain'. I allow myself
the conceit that Colquhoun edited her essay specifically for my
generation, preparing a primer so that she could tutor we restless
children and introduce us to her mantic vision of the universe.
The dictionary definition of 'mantic' is that of divination and
prophecy, with a touch of divine madness thrown in for good
measure. It's a long way from Enid Blyton.

There are three stages to creating a mantic stain as advocated
by Ithell Colquhoun. Firstly, marks are made by prescribed chance
methods upon paper or canvas, after which there follows a period
of contemplation of those marks to discover the 'mind pictures'
therein, before finally, the stain is developed in plastic terms.

*It is hardly necessary to point out that the same unconscious process, which
makes a mantic stain and recognises its pictorial scope, also selects and
illumines that morsel of external reality which constitutes a 'found-object'.*

I have involved all of my senses in my own exploration of the
mantic stain. I've pondered the possibilities of mantic perfumes,
a mantic raga, a mantic carpet that could be contemplated in much
the same way as a seer stares into a scrying glass, or a mantic
dress that would prophesy the wearer's destiny.

I also like to think of a misfit gang in a small northern town with
'Children of the Mantic Stain' daubed across the back of their
jackets in much the same way that I'd seen 'hate' and 'anarchy'
painted across trousers and t-shirts in 1976. The possibilities
of a mantic dance have been central to my thinking. While my initial
thoughts were Busby Berkeley meets Mary Wigman, now the dance
is so cocooned in automatism that it's difficult to discern its form.
And so it went on. Where Ithell Colquhoun led, I followed. With her
encouragement from beyond the grave I picked up paints again
for the first time in 40 years and let them spill mantically over the
pages of 1980s naturist magazines that I'd found in a second-hand
bookshop in Penzance, yards away from the gallery where Colquhoun
had last shown her work in 1981.

*Diagrams of Love:
Marriage of Eyes,
2015 (details)*

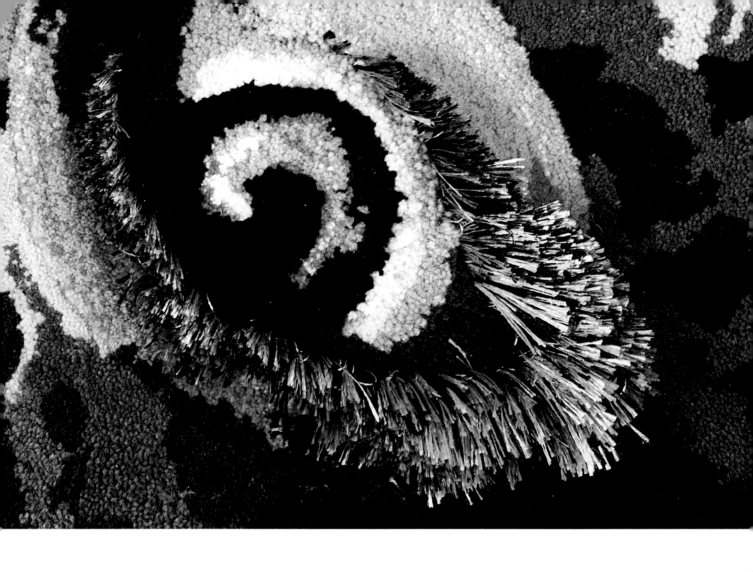

During this exploratory time in 2014, I spent a week at Raven Row gallery in London, staying in the apartment of the late Rebecca Levy who had died there aged 98 in 2009. Since Rebecca's apartment has remained very much unchanged I found myself immersed in her domestic world and most of all, her choice of carpets. They became my 'morsels of external reality', as effective as any mandala for prolonged contemplation.

Shortly after my stay at Raven Row, I was approached by the curator Andree Cooke on behalf of Dovecot Studios to create a rug of my own design. I worked with Jonathan Cleaver, Dennis Reinmueller and Vana Coleman to translate Ithell Colquhoun's essay into tufts of multicoloured wool, also managing to incorporate the patterns of Rebecca Levy's carpets to create a twenty-first-century version of a magic carpet.

Ithell Colquhoun quotes fellow surrealist Dolfi Trost in her essay and his advocation of 'superautomatism' and 'letting a line go for a walk'. To further liberate the plastic form of my rug, *Diagrams of Love: Marriage of Eyes,* we made an incision in the shape of a spiral so that it too could go for a walk. Dancers from Northern Ballet then transformed that walk into a mantic dance. The choreographer Kenneth Tindall and I never let ourselves have an easy time translating art history into an adagio; in 2012 we worked together to create an homage to Barbara Hepworth, which resulted in the ballet *The Ultimate Form.*

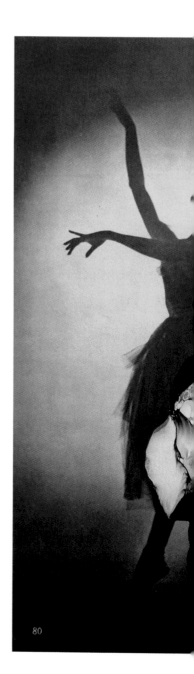

Every ballet dancer needs a costume, and the fashion designer Christopher Shannon entered Ithell Colquhoun's intellectual 'multitudinous abyss' to design costumes that reroute her mid-twentieth-century writings into sportswear that could have been worn by teenagers at the Drome Club in Birkenhead in 1992. And what of my musings on the possibility of a mantic raga? The film composer Maxwell Sterling has written a score of eight sonic 'stainscapes' for the ballet, in which each musical motif influences the other horizontally, as well as vertically.

It's safe to say that Ithell Colquhoun's children of the mantic stain are very much alive, well and uninhibited.

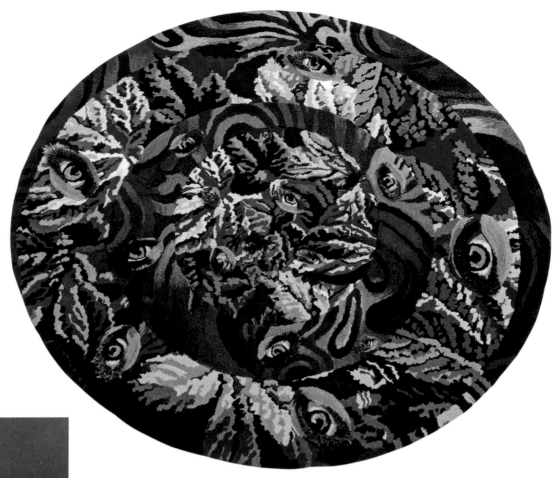

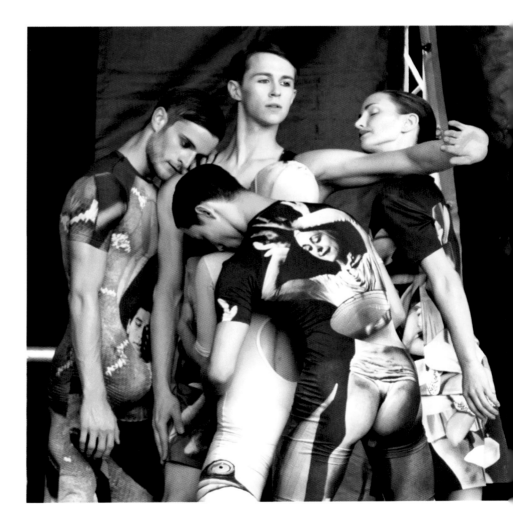

Superautomatism Grand Jeté I, 2015

Diagrams of Love: Marriage of Eyes, 2015
The Ultimate Form Ballet, 2013

Rachel Maclean

A delirious confection of multi-layered digital images, whipped
into even more extravagant form by the artist's trademark
multi-character theatrics, Rachel Maclean's *Feed Me* is an audacious,
provocative exploration of the commercialisation (and sexualisation)
of childhood, and a corresponding infantilism in adult behaviour.
Produced by Film and Video Umbrella (FVU), this is Maclean's most
ambitious project to date. Part fairy tale, part hyper-modern
fantasia, it is a parable of the pleasures and the perils of excess.
As we feed the monster of contemporary consumerist desire,
Maclean's film is a record of all the little monsters that are
created in its wake.

Steven Bode, Film and Video Umbrella (FVU)

Feed Me, 2015

Ahmet Öğüt, with Liam Gillick, Susan Hiller and Goshka Macuga

Ahmet Öğüt presents *Day After Debt (UK)*, a long-term collaborative project that tackles student debt. For the UK version of the project, artists Liam Gillick, Susan Hiller and Goshka Macuga have been invited by Öğüt to design sculptures that function as collection points for public contributions to student loan debt relief. The three bespoke money boxes will be installed in civic spaces around the four cities of *British Art Show 8*, generating income which will be redistributed by the Jubilee Debt Campaign. As part of the project Öğüt worked with lawyer Daniel McClean to develop a 'Letter of Agreement' between the artists and potential future owners, so that all present and future proceeds collected by the sculptures will go to the campaign.

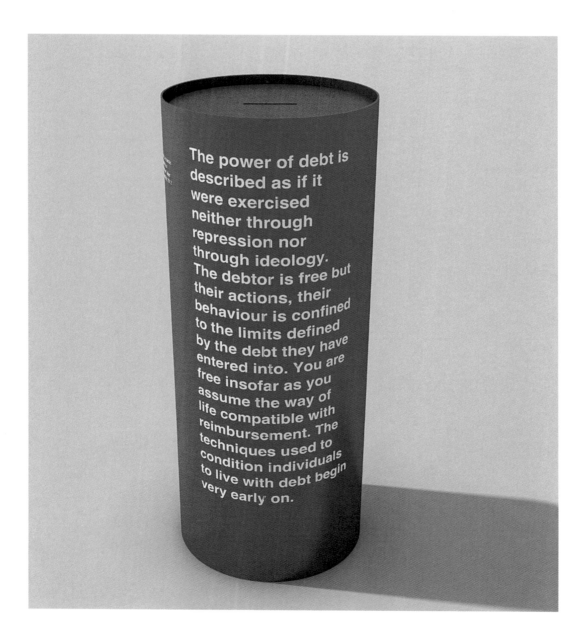

Liam Gillick
Lazzarato on Debt, 2015 (preparatory sketch)
Part of Ahmet Öğüt, *Day After Debt (UK)*, 2015

Goshka Macuga
In Debt View, 2015 (preparatory sketch)
Part of Ahmet Öğüt, *Day After Debt (UK)*, 2015

Susan Hiller
Thanks for Listening, 2015
(preparatory sketch)
Part of Ahmet Öğüt, *Day After Debt (UK)*, 2015

Yuri Pattison

Yuri Pattison's new sculptural work features footage produced in
close collaboration with the Chief Marketing Officer of a company
operating a Bitcoin mine; a large specialised data centre, in
Kangding, China. In Bitcoin mining, individuals or groups use a
complex networked computational process to release new Bitcoins,
the most widely used decentralised digital currency. The outsourced
footage in this video includes a first person view of the Bitcoin mine,
the neighbouring government-constructed hydroelectric dam and
the surrounding Tibetan natural landscape. Presented alongside
objects referencing and replicating the mine's energy intensive
processes and alluding to the technology's alchemistic promises
– what the artist calls 'relics of the present' – Pattison's work
uses the example of Bitcoin mining to explore the interconnected
anxieties of shifting power, exchange, production and consumption
in a global-networked economy still dependent on fossil fuels.

The Ideal, 2015 (production images)

HaoBTC Bitcoin mine in Kangding,
Garzê Tibetan Autonomous Prefecture,
People's Republic of China, 2015
(production image)

RELiable COMmunications
(http://reliablecommunications.net/), 2013

Ciara Phillips

"*Workshop* first came about as a response to a curatorial project at Hamburg Kunstverein (2010) where I was one of several artists invited to consider 'the potential of the exhibition format as a site of production and a framework for collaboration'. That proposition was the catalyst for deciding to set up a temporary printing studio in the gallery. In a sense it was quite pragmatic – I needed a space in which to work – but it was also a chance to pick up on a longstanding interest in working collaboratively with other artists."

From 'Roundtable on Production', p.94

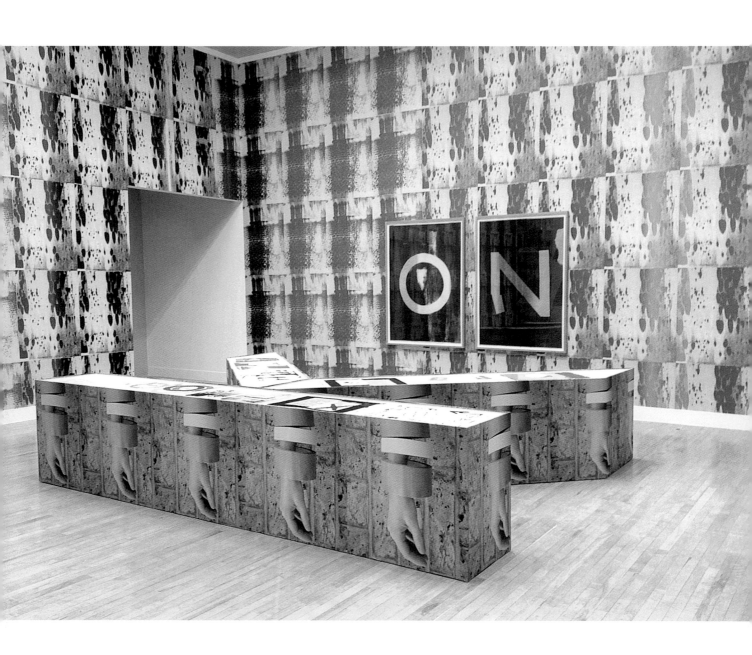

Justice for Domestic Workers printing in *Workshop*, (2010-ongoing)

No 2 Slavery banner made in collaboration with Justice for Domestic Workers, 2013

(installation views: The Showroom, London, 2013)

Things Shared, 2014
(installation view: Tate Britain, London, 2014)

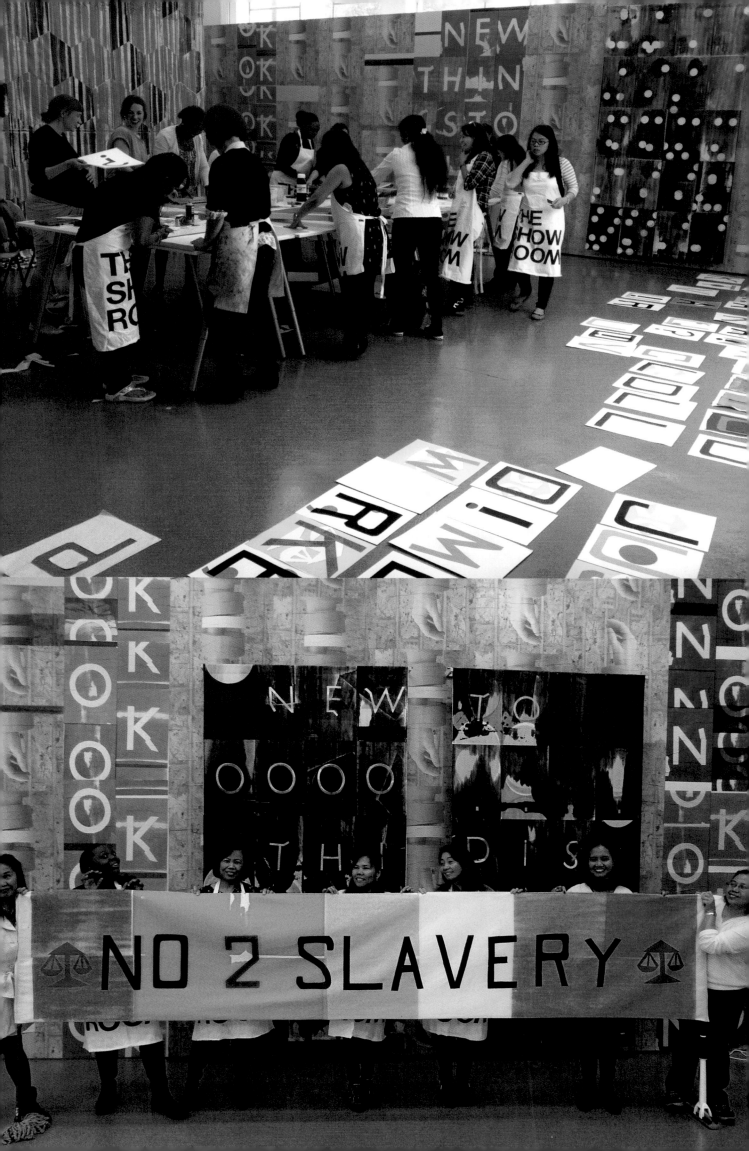

Charlotte Prodger

Charlotte Prodger's installation *Northern Dancer* (2014) was commissioned by The Block, a company that restores discontinued Hantarex and Sony video monitors. It comprises four repurposed video monitors, across which flashes a series of seemingly arbitrary words. These words are in fact racehorse names following the ancestral bloodline of a particular thoroughbred horse named Markets, reflecting a convention when naming racehorses of splicing the names of the parent stallion and mare. The accompanying voiceover describes a particular moment in the lives of Gertrude Stein and her lover Alice B. Toklas concerning the obliteration throughout one of Stein's manuscripts of the word 'may'; both a linguistic rebuttal and a 'striking out' of the author's former lover, May Bookstaver.

Northern Dancer, 2014
(installation view: Chelsea Space,
London, 2014)

	B 1	F 1	B 2	F 2
	NORTHERN DANCER	HIS MAJESTY	PAS DE NOM	SPRING ADIEU
	RAZYANA	DAN		ZIG
	STAR KINGDOM	IDOMENEO	KAORU	MODERN TOUCH
	KAORU		STAR	PROMISING
	STAR KINGDOM	PORT VISTA	OCEANA	VALIANT ROSE
		MISS PORT	TODMAN	
	S W E	E T	E M B	R A C E
	RAISE A NATIVE	PARDAO	GAY HOSTESS	VANITA
	CROWNED	SWEET	PRINCE	LIFE
	BELLBOROUGH	INFATUATION	ADDITION	ZANZARA
	BELLITION	SHOWDOWN	BELLTITION	
	KAORU STAR	WILKES	PROMISING	PUPPET
	LUSKIN STAR			ANJUDY
		ROYAL PROJENY		
	BISCAY	SIR IVOR	NUNKALOWE	ISOLT
	BISCA		LOWE	SIR TRISTRAM
	RAISE A NATIVE	SIR IVOR	GOLD DIGGER	FRANFRELUCHE
	MR PROSPECTOR			GRAND LUXE
	ROLLS	ROLLS	ROLLS	ROLLS
	SHOWDOWN	CROWNED PRINCE	BELLITION	SWEET LIFE
	THE JUDGE			SUMMONED
	LUSKIN STAR	SIR TRISTRAM	ANJUDY	BISCALOWE
	ROYAL PROJENY			MARAUDING
		SOR	TIE	
	DANZIG	MR PROSPECTOR	RAZYANA	GRAND LUXE
	DANEHILL			ROLLS
	KAORU STAR	TODMAN	PROMISING	MISS PORT
	LUSKIN STAR			SWEET EMBRACE
	S U D	D E N	I M P	U L S E
	MARAUDING		ROYAL PROGENY	
		THE JUDGE		SORTIE
				SUMMONED
			ZEDITAVE	
	DANEHILL		ROLLS	
		FLYING SPUR		
		LUSKIN STAR		SWEET EMBRACE
		SUDDEN		IMPULSE
	FLYING SPUR		SORTIE	
		RETAIL THERAPY		
		ZEDITAVE		SUDDEN IMPULSE
	STRATEGIC	STRATEGIC	STRATEGIC	STRATEGIC
				RETAIL THERAPY
			STRATEGIC	
		RETAIL THERAPY		
			STRATEGIC	
			STRATEGIC	

Laure Prouvost

Electronic cigarette:	I can light.
Butter:	How can you light? You're just a... an electronic cigarette.
Electronic cigarette:	You turn me on.
Butter:	I can turn you on and off like that all the time [clicks fingers]. I just turn you on and off like this. I would do anything for you. [Laughs.]
Electronic cigarette:	[Laughs.] You're naked. I just wanna... I just wanna spark on and spark off. That's all I want to do.
Butter:	[Laughs.]
Electronic cigarette:	It's all I wanna do. I wish I was in your lips.
Butter:	In mine or in the person's who's looking at us? I wish I was next door not here.
Electronic cigarette:	Oh don't go next door.
Butter:	Next door is where it's all happening. We're just two little things now left alone that no one cares about.
Electronic cigarette:	But I can be any colour you want. I can be blue if you like.
Butter:	Well, can you be red? [Clicks fingers. Laughs.]
Electronic cigarette:	[Laughs.]
Butter:	[Laughs.]

The e-cigarette and the butter, 2014

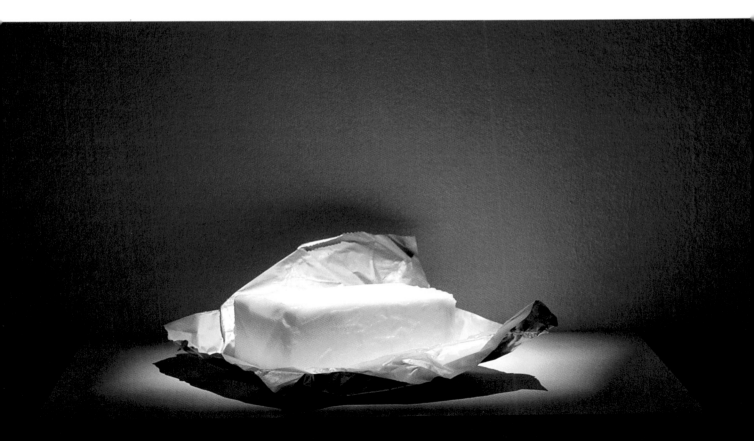

Lawrence Abu Hamdan
Melanie Gilligan
Ahmet Öğüt
Ciara Phillips
Patrick Staff

In conversation with Anna Colin and Janna Graham

Roundtable on Social Relations

Anna Colin: Ahmet, for *Day After Debt (UK)* (2015) you have invited three artists – Liam Gillick, Susan Hiller and Goshka Macuga – to design sculptures that will act as donation boxes to relieve student debt. You have also initiated a partnership with Jubilee Debt to manage and distribute the funds generated during the exhibition, and include the legal contract with the artists and future owners of their work as an integral part of the project. *Day After Debt* contributes reflections on utility, solidarity and ownership and, importantly, it has longevity outside of the exhibition: the works are intended for sale and permanent display in the public realm, continuing to fulfil their utilitarian function. If the theme of student debt is a very potent one, it seems to me that it's almost a pretext – albeit a meaningful one – to propose alternative collaborative, social, economic or legal models.

Ahmet Öğüt: Yes. I recently attended a talk by the Detroit Workers Action Committee, where the presenter was talking about modern-age capitalism and how manufacturing used to be at the centre of it, but has now been replaced by what used to be basic human rights, such as [access to] education or water. These rights have become the biggest profit-making operations. So you're right in a way: it doesn't matter if we talk about higher education fees or water bills, as these topics are interchangeable. What we need to figure out is their link to economics and social life.

When developing a project like *Day After Debt*, the most important questions I ask myself are: how can things be shared and distributed beyond the scope of artworks, ideas or campaigns? What happens afterwards? What's the project's afterlife likely to be and what will it produce? Even if a project has been planned in collaboration with various experts over time and with the future in mind, there are a lot of unknowns, which we shouldn't ignore. I would question how to continue it and in what way, since most of the ideas are beyond us, beyond one person's capacity.

Day After Debt requires a lot of long-term engagements and collective involvement – from me, the artists, the campaign organisation, the lawyer, the project's partners and curators. The possibility of a take-over or transfer – for example of the initial idea – is also interesting to me. Instead of always coming up with a new idea, I think it's good to rethink, repurpose, recycle the things that have already been done, tested, failed or achieved. We have a lot to learn from past approaches and should connect with these as well as add to them. In a recent text, I mention the 198 methods cited by Gene Sharp in his 1973 guide to nonviolent action[1] – we should always work towards growing this list of strategies and actions.

AC: Lawrence, the work you are presenting is the latest instalment of a project that investigates new, unheard aural perspectives. In 2014 you met with a team of computer scientists at MIT who have shown that mundane objects, such as

1. Gene Sharp, *The Politics of Nonviolent Action* (Boston: Porter Sargent, 1973).

bags of crisps, are picking up sounds and generating small vibrations that can be retrieved using a high-speed video camera. In a not-too-distant future, every object might be turned into a listening device, opening new surveillance opportunities as well as perspectives for the material world. You refer to your project as a form of whistle-blowing, letting the world know about the imminence of a new form of scrutiny, 'before our own clothes start spying on us'. Some of your recent projects have set models and precedents in fields outside of art: do you see a distinction between your aesthetic practice and the agency your work might have outside of art, or is it all part of one and the same thing?

Lawrence Abu Hamdan: I find it counterproductive to think of myself as an artist who works in the 'fields outside of art'. Similarly, it is not productive for me to make a distinction between conceptual and aesthetic practice on the one hand, and 'real life' use-value on the other. I am not saying that art is inseparable from real life nor that every work of art is political, but rather that for me the question of being useful is a conceptual and aesthetic challenge to engage with as material for artistic practice. So it's not as if the conceptual work is separate from the space and form of its exhibition, but rather they are entangled. For me that question extends to the works that have lived as Islamic sermons, expert testimony, advocacy campaigns, just as it does for white cubes and theatres. In this regard I see my works not as being 'used' in things like advocacy campaigns but rather about how the role of the artist as an aesthetic practitioner can expand and challenge the whole ethical and practical notion of 'use' and 'usefulness'. The end goal is not for the work of art itself to be used by advocacy campaigns and activist practices, but for the work of art/artifice to inhabit these spaces in order to expand what can be considered advocacy, journalism, testimony, etc.

A recent audio-ballistic analysis I worked on for Forensic Architecture and Defence for Children International became an interesting frame to think through these questions. Here I was asked if I could prove that the Israeli Defence Forces were firing live ammunition and not rubber bullets (as they claimed)

at unarmed protestors. I could not hear the difference in the sound samples until I produced images and spectrographs – until I could see the sound. So the aesthetic labour of making these images was what allowed me to hear the distinction in the gunshots, a distinction which was essential for the advocacy campaign. There was no distinction between the investigative labour and the aesthetic practice: rather than simply being illustrative, the images themselves were investigative.

The large-scale map of the potential ability of everyday objects to eavesdrop I am making for British Art Show 8 is the cartography of a potential world to come rather than an investigation of our current context. This rather paranoid map of the auditory capacity of everyday objects allows us to think through science before its application in the surveillance empire. The scientists who develop these things are actually interested in vibration and not spying – for them the most interesting part of this discovery is not that objects can record us but that for the first time we can hear like objects, listening to the world from the aural perspective of potato-chip packets. Pre-empting these technological advances by making these artworks is for me a way of opening up a discussion about other potential applications for this technology than surveillance.

AC: Melanie, The Common Sense (2014) picks up on some of the conditions and desires projected in Popular Unrest (the multi-episode drama you directed in 2010), such as experiencing deep connections with other people and wanting to feel what others feel. Like Popular Unrest, The Common Sense is a sci-fi drama set in a near future that resembles all too closely our present, riddled by debt and flexible labour. The protagonists live in the era of 'the Patch', a wearable device that enables one to experience another person's bodily sensations and inner feelings, but soon becomes controlling of both labour and social relations. Could you talk about the links between the two film projects, and about the Patch as a technology of the future?

Melanie Gilligan: The main link is that both films deal with collective social relations today. Popular Unrest shows a group of people who are

mysteriously drawn to one another, who reshape their lives around this collective situation. Later on in the story they find out that what prompted them to come together was – through various turns of the plot – actually the structures of exchange relations in society. Although the collective desires they have are very real and important, the plot presents the ways that their lives and subjectivities are shaped by market relations. *The Common Sense* similarly tackles present-day obstacles to the collective and to collective resistance by looking specifically at how collective aspects of labour are made economically useful. While the technology may bring to mind contemporary phenomena like the 'sharing economy', the sci-fi premise pushes us to possibilities beyond the present to ask us to imagine something that is hard to imagine – the experience of subjectivity as overlapping with that of another.

Technologies often allow us to be more productive – the smartphone allows people to reply to emails quicker. This productivity sets up new social norms that then become indirectly enforced through society at large. From the start of *The Common Sense* we see that the Patch becomes more productive, enabling new types of work and communication and allowing the possibility of regulating all sorts of previously intangible aspects of employees' subjectivities. However the technology also holds new potential to re-organise the subjectivity of those who use it to become more collective. In the course of the film we see both an early moment of the technology's release when its impact on society is just being felt, and a later point when it has already deeply transformed many social conditions. In the earlier timeframe many people had held expectations that the technology would bring about a period of collective struggle, however by the later period we see that these possibilities were not adequately explored. Instead the way the Patch is used opens up a new commodification of experience and exploitative sharing, since the technology is a product of the economy in which it's being used.

AC: To continue with you, Patrick, your film takes as its starting point the artist Tom of Finland and the house he lived in, in Los Angeles, now a foundation dedicated to preserving and raising

awareness of his erotic artworks. But the true subject of the film is the community that inhabits that space. Your work has previously delved into similar territories, exploring the formation and equilibrium of intentional communities, and your own position within them. Unlike some of your projects, which have been more spontaneous and improvised, this particular work has taken you a long time to develop. Could you talk about that process, and more specifically about the conversation you have established between yourself and the community you have filmed?

Patrick Staff: I first visited the Tom of Finland Foundation in 2012, on a friend's recommendation. I went there expecting a 'typical' archive (receptionist, appointment, white gloves, concrete building), but instead found it to be a community of people living and working together in a three-storey clapboard house. Spending time there, I learnt how the house had been bought and set up as an intentional community of gay leather men in the 1970s. They hosted Tom of Finland (Finnish artist Touko Laaksonen, 1920–91) in the latter part of his life spent in Los Angeles, and in the 1980s formalised themselves to preserve his vast catalogue of homoerotic art, whilst endeavouring to 'educate the public to the cultural merits of erotic art and in promoting healthier, more tolerant attitudes about sexuality'.

What struck me most about the foundation was not knowing immediately who lived there, worked there, was volunteering or just hanging around. I quickly felt welcomed into that space – in parts, I was aware, because of my appearing male – sharing food and talking, looking through the archives, the domestic spaces, as well as the dungeon and 'pleasure garden'. I was immediately sensitive in that house to thinking about the nature of intergenerational queer relationships; the relationship between gender, inheritance and cultural memory; and perhaps, most of all, of care: care for the individual's body, for a body of work, for the literal bodies of a community. I wasn't interested in making a work *about* that place, the people or Tom himself, but began to try to formulate something made *with* all of them. Over time, it became increasingly about understanding my own queer, transgender identity and about interrogating

the body as a living political archive. How embodied knowledge and gesture became important to my thinking, as did the literal, material environment that held this archive. I feel that in making these types of works - ones that seek a making *with* communities, in collaborative forms - what is often sought by those interested in them, is a model for ideal collaboration, and an idealised equalising of power. Yet, in many ways, my practice over the years has had to find a way of incorporating inevitable inequality, and has had to embrace it in some way. This isn't always easy.

AC: To finish the round with you Ciara, you are presenting a new iteration of *Workshop* (2010-) by setting up a temporary studio and inviting groups to experiment with and converse around printmaking. You have said that you are interested in the radical possibilities contained in the screenprinting medium - its immediacy, its portability, its communicability - and often quote the inspirational artist, tutor, campaigner and peace activist Sister Mary Corita Kent. In the situations of collaborative work you create, how do you communicate what you know about printmaking to others that don't? Or put differently, what's the role of pedagogy in this project? And what do you personally learn in the process, especially after a few years of doing it?

Ciara Phillips: I've never really thought of *Workshop* as a pedagogical project but it does draw a lot on my experiences as a student and teacher, and I think it plays host to a lot of learning. *Workshop* first came about as a response to a curatorial project at Hamburg Kunstverein (2010) where I was one of several artists invited to consider 'the potential of the exhibition format as a site of production and a framework for collaboration'. That proposition was the catalyst for deciding to set up a temporary printing studio in the gallery. In a sense it was quite pragmatic - I needed a space in which to work - but it was also a chance to pick up on a longstanding interest in working collaboratively with other artists.

My first venture into collaboration was as a student on a multidisciplinary fine art course in Canada. In my final year of study, two friends (Jennica Hwang and Liza Stiff) and I made all of our art together. We worked with painting, video, print, sculpture, performance and installation, and it was a hugely important and exploratory time. I remember spending long hours in our shared studio, and also in the print facilities where we had lots of room to work together. That's something that still interests me about print: that it's often produced in shared space. Artists pool resources for practical reasons but there is an element of skill and idea sharing that comes about through necessity.

When inviting people to take part in the *Workshop* project with me now, I try to approach any potential collaboration in as open a way as possible. If I set up a framework it's generally quite loose - let's make a publication together, for instance. Mostly I'm interested in talking to people about the things that matter to them and I enjoy doing that through the process of making things together. I get a lot out of working alongside other artists, designers and community groups and that's why I'm still interested in continuing *Workshop*. It's always a challenge to my own position and pushes me to think carefully about what really matters to me and how to communicate that. I hope my collaborators get something from it too, but it's more difficult for me to articulate what that is.

Janna Graham: Hi everyone, I wanted to jump into the conversation and delve deeper into something that all of you touched on, which is the question of use. This I think was inherent in all of Anna's questions and is therefore of some importance to the exhibition, but also when we think of questions of collaboration more generally: collaboration with whom, and for what? Ahmet, you describe art projects exceeding their artistic timeframes in the service of political struggle. Lawrence, you discuss the importance of re-framing the terms in which we understand usefulness. Patrick and Ciara, you each approach collaboration in terms of mutual aid, support, care and collectivisation of resources. And Melanie, you point to how politically progressive aims and useful tools are in turn used to govern our bodies and lives. The question of use plays out in the organisational aspect of art, the commissioning, supporting and material and immaterial conditions under which it is produced.

That is the authorial distinctions we inherit, the colonising institutions we must navigate, the timeframes we must adhere to, the corporations and individuals we must increasingly woo and the low wage, insecure and psychologically precarious conditions we inevitably normalise.

Ivan Illich questioned the 'helping professions', describing their problematic role in shaping needs, and by so doing, vertically integrating needs and uses into capital and incapacitating the collective work of others. Though I know art is not explicitly a helping profession, and often works against these very tendencies, the question of use raises questions around how the need for something that becomes useful is shaped and by whom.

MG: I find the question of use an interesting one to discuss. I don't generally have a notion that an artwork has to have a usefulness, but in my narrative video series I've been very happy when the works have been judged to be relevant or catalysing of discussions or situations. Perhaps the question of use can also be thought about in relation to my videos existing in a space between art, TV, cinema and web content. Or at least my work refers to these other discursive fields. We end up with questions such as: what is the comparative intellectual, political, affective impact of a work or a film? But also, how does an ostensible change in context affect the reception of a work? This has a very different effect than when I was making performances that equally involved writing scripts which were performed by actors. But because I wasn't trying to insert them in or have a relation to recognisable industrial systems the question of the works' usefulness never came up for audiences. Like I say, this would seem to relate to whether or not one is explicitly indicating some notional external limit of art.

When *The Common Sense* was in its early stages, back in 2011–12, I was able to make the premise of the work an object of discussion. I had public conversations about issues that came out of it, questions such as how technologies change us, our attitudes, our behaviour and our bodies, how the Patch might alter the relation between self and other, individual and collective, and also between subjects and their economic survival.

Understanding that the physical conditions of individual existence would be remade by the technology, but that these changes would be dictated by the needs of capitalist accumulation, I came to think that these outcomes were more problematic than positive. As a stage of the larger process, these discussions helped me to get to grips with how social contact between people forms subjectivity, how structural conditions affect such contact, and how political possibilities are shaped by these interactions. The Patch was a useful device for getting some grip on these processes, developing specific questions about them. During this process, I published some ideas on the work in development, which I later reconsidered and generally learned from putting the process in the world.

PS: It's interesting to think of this question in relation to the Tom of Finland Foundation, which to my understanding, was founded upon a feeling of needing to legitimise the work of Tom of Finland and position it in the world of fine art, as opposed to pornography. This meant restricting and rarefying its circulation, as well as fixing its various qualities (e.g. *Untitled*, 1976, graphite on paper, etc). It also meant shifting what was formerly a commune into a foundation, a charitable organisation and an archive. I feel like my project begins to propose a counter-narrative to that of an institution, wherein a lot of the issues your questions are raising are already being played out. For me, it became important to move away from a study of counterculture versus the mainstream, or the institutional and anti-institutional, to a focus on constitution.

CP: My own experience of making collaborative work within an institutional context has been, for the most part, very positive. I don't think the *Workshop* project could have developed the way it has without the critical, administrative and financial support of the institutions that have hosted it to date.[2] To say that these organisations 'hosted' the project feels somewhat unjust as it doesn't truly credit the time and effort committed to it by the curators and administrative staff. In the end, support isn't just about resources but also about a much wider investment in wanting to make

2. Hamburg Kunstverein, Spike Island, Bristol, and The Showroom, London.

something happen together. Several of the collaborations I've been involved in over the past few years have come about through introductions to other artists, designers and groups made by the 'hosting' organisation. While I initially approached these proposals with some scepticism, I've learned that there's a lot to be gained from trusting the motivations of the people who want to support the development of art in general, and my work in particular. I don't wish to sound as though I'm advocating blind faith in the institutions of art, I think it's just a case of being conscious of what the motivations of the organisations you chose to work with are.

JG: So the use for these projects lies in their capacity to think through another kind of organisation. But still, the field of art itself creates certain conditions of organisation, one of which is to produce a narrative distinction between art and the rest of the world. How are you and your collaborators' concerns heard or manifested within these conditions? What are the inherent conflicts? Are there ways that the contradictory terrain is useful to broaden and complicate projects? Or is it really the only option for survival?

LAH: This question comes close to my interest in how we are being heard today and the role of art in producing alternative conditions for listening. In 2012, I made a work called *The Freedom of Speech Itself*, which looks at the history and contemporary application of forensic speech analysis and voice-prints, focusing on the UK's controversial use of voice analysis to determine the origins and authenticity of asylum seekers' accents. In 2013 this work was used as expert evidence and I was called to give testimony in the asylum tribunal.

When I was in the courtroom I was asked if in my opinion the whole issue of language analysis for the determination of origin should be scrapped, or if it should be simply reformed. I answered that it should be scrapped (in fact I think the whole border should be scrapped) in line with several linguists who agree with me. Afterwards, the defence lawyer told me he didn't like that the judge had asked me that question, and the reason why he didn't like it was that he was trying to turn me into a radical. If I were

to answer that it should be scrapped, which I did, then I would be performing some kind of bias and therefore my testimony could be nullified, regardless of the evidence I had presented. This points to something very dark about the notion of free speech: we can say whatever we want but there are certain points when what we say exceeds what is audible in terms of a 'rational' claim. What I'm trying to get at here is that I participated in this case because I wanted to help the person who I was testifying on behalf of. But I don't see this action being close to anything that is truly going to effect change because I'm simply speaking within an audible range of what is accepted within the confines of the law.

I am frequently disappointed with the way that law as a realm of practice is becoming more and more accepted and desired by artists and curators, where many projects are produced in which the idea of exceeding the boundaries of art and doing something 'real' has simply become equivalent to working with legal professionals and attempting to speak the esoteric language of legalese. I am disillusioned with how law is thought of, that is as the only space of legitimate action, where things can be enacted and changed. It's a space in which precedents slowly mutate something into being more acceptable: a lesser evil that is maybe freer or maybe less unfair. But as a sphere of action it is something that I would insist is inherently conservative.

In contrast, the white cube is still a space in which speech is not libel to anything: you can say what you want and it would be difficult to take one to court over it. That shaping of the conditions of listening is for me one of the most important parts of political practice, and working with museums and galleries opens up ways in which we could experiment with political action and the unresolved questions of having a voice in today's democracy.

PS: I was drawn and felt sensitive to the Tom of Finland Foundation as an institution, and aware that I was making a work that would then be seen in a group of very different institutions.[3]

3. Chisenhale Gallery, London, Spike Island, Bristol, Institute of Modern Art, Brisbane, and Contemporary Art Gallery, Vancouver.

The body of work I have made – *The Foundation* – could not be 'hosted' by the actual foundation, and large portions of the work in their archive have no currency in the galleries where my work will be seen.

My thinking is often centred around legitimacy: does presenting this work – this set of concerns – in the context of an exhibition make it a legitimate endeavour? Does it make my potentially illegitimate identity a legitimate one? Does it make it so simply because I have a platform with which to express it? And if so, to whom and on what grounds? These are questions I have returned to frequently in my work, focusing on the currency of the body. Trying to ask these questions involves constant compromise and negotiation, yet doing so in the context of art offers an arena that very few other spaces do.

MG: I'd like to respond to one part of the question on the repeated narrative distinctions made between 'art' and the rest of the world. My narrative film projects sometimes elicit questions about whether those works are too much of the world (by being focused on structural issues in the present, or by using popular non-art forms) to work as art. At least I used to get this, and in some environments it is still a reading I get because those works are considered by some to not deal with questions particular to art. I see narrative as something to consider aesthetically and in terms of form. Equally I see the ways through which I tend not to preserve differentiation between art and the rest of the world – for instance, through the films, doing theoretical work or engaging in a political or economic discussion as decided by relationships within the artwork, which will be, for example, different in my serial narrative videos than in other works.

AÖ: Going back to the question of use, that notion is important, but it is hard to to think about it separately from the question of 'use-value'. As you mention, in his writing, Ivan Ilich addresses this necessity of struggle for an equitable distribution of the liberty to generate use-values. In an ideal world we should easily be able to imagine museums as social power plants and artists as effective initiators who

are able to respond to current urgencies, able to challenge and transform civic, legislative, pedagogical, cultural and economic hegemonic structures. But when we look around, we see many institutions that are struggling with economic, humanitarian and natural disasters, and artists who are like crippled bodies oriented around their own survival while trying to make the world a better place with their micro- and macropolitical projects. For me the only way to confront these contradictory terrains is to find more and more ways of connecting counter-financial strategies and socio-cultural production. Here I'm not only referring to specific means of art production; I'm not in favour of dividing production of art into subcategories. I think any kind of art production is subject to this very same question.

Magali Reus

"The works in the *Leaves* (2015) series act as small moments of specific architecture, which might become a means of classical organisation. As deeply mechanised objects which act as metaphors for content that is just out of reach, the lock (or padlock) could be considered a signifier for concealed information, domestic privacy and social security. Comprising multiple levels of engineered metals, plastics and cast components, these works use the calendar as a model for repetition and speed: days of the week, numbers and seasonal changes in colour or density are all housed within a larger, enveloping casing. As densely decorative forms, they act as framing devices for information: the time of a dentist appointment, when to water the plants, birthdays, anniversaries, deadlines, deaths."

Leaves (Peat, March), 2015

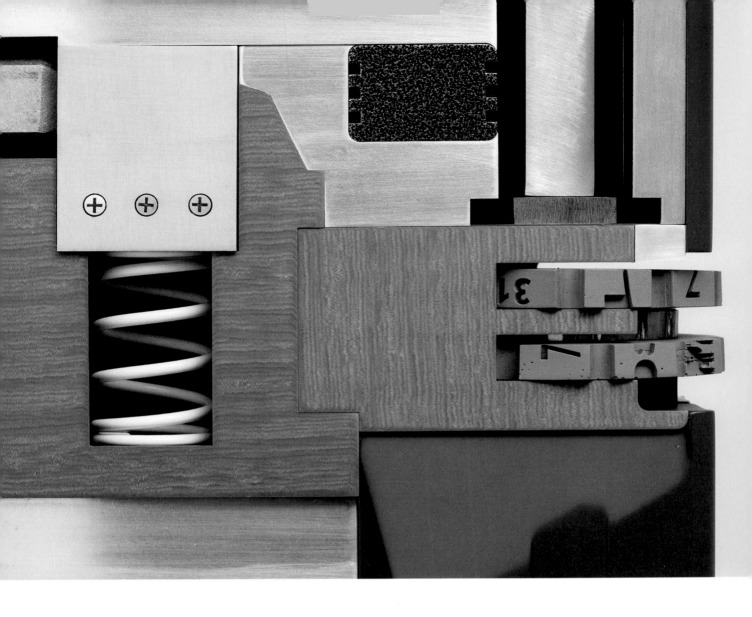

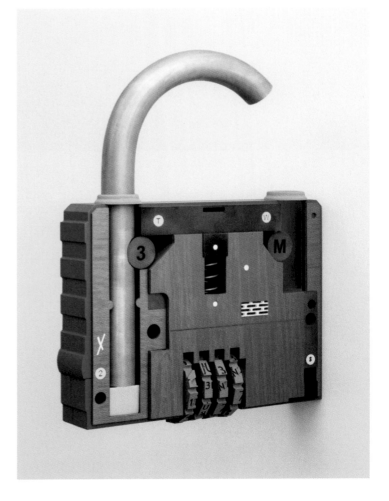

Leaves (Tricks, September), 2015 (detail)

Production image, 2015

Leaves (Dale Arches, June), 2015 (detail)

James Richards

James Richards' film *Raking Light* (2014) is a montage of moving image
that the artist sourced online, took from cult films such as Stanley
Kubrick's *A Clockwork Orange* (1971), or filmed himself. Short clips,
mostly black and white, appear and then reappear as solarised
or negative images, reversing the pictures' original tones. Richards'
painstakingly assembled images are accompanied by a distorted
and disjointed soundtrack of sampled music and ambient sound.

Raking Light, 2014
(installation view: Cabinet, London, 2014)

Raking Light, 2014 (film stills)

Eileen Simpson & Ben White

"For *British Art Show 8* we harvest copyright-expired chart hit records from 1962, the last retrievable from the public domain until 2034 due to legal revisions. Hacking emerging information retrieval technologies, we strip away proprietary elements to generate a 'public sonic inventory', which provides a soundtrack for a new audiovisual work, assembled during the exhibition tour. The project contributes to Open Music Archive, our ongoing work to source, digitise and distribute out-of-copyright archive material and to spark collaborative activity through exhibitions, films and live events. The work is situated at the intersection of art, music and information networks and critically engages with modes of circulation and their related legal and economic systems."

The Decibelles sing 1963 hit 'Be My Baby'
by The Ronettes, 1983

1962 chart hits
45 rpm vinyl records

Daniel Sinsel

"I am spelling out the name HÄNSEL. (Hänsel and I share the same number of letters as my first name and my surname, and share several of the same letters). Hänsel (usually anglicised as Hansel) was Gretel's brother. He was captured and fed by a witch who was planning on making him into a roast dinner. His sister managed to rescue him. I love old stories and making them material. I like the safety of stories of the past: to feel their destabilising terror and their sensual allure. I aspire to embrace their mysterious potential with innocent generosity."

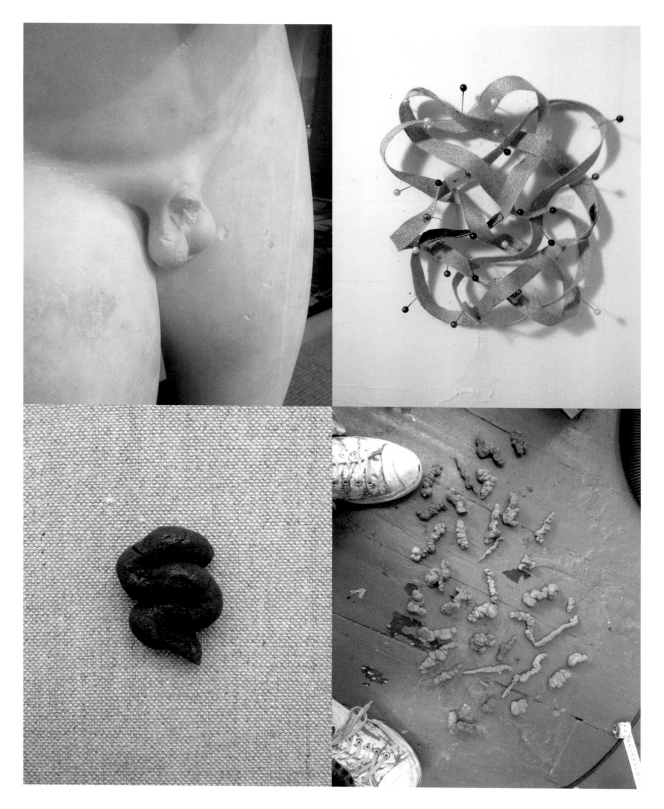

Production images, 2015

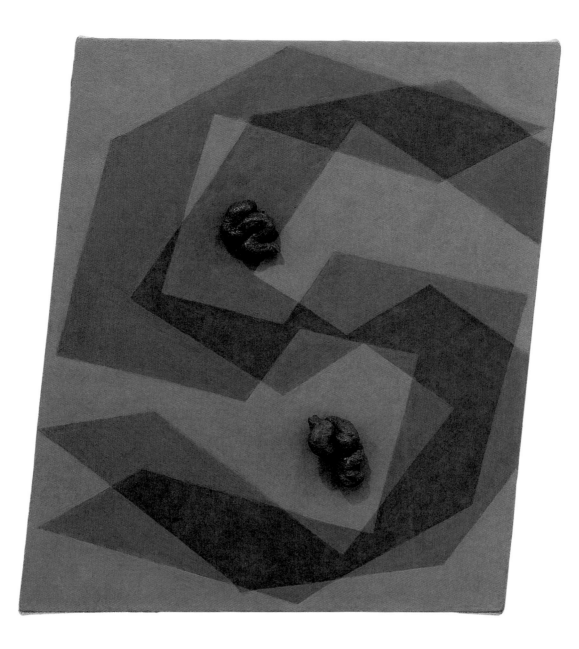

Untitled, 2015
Untitled, 2015

Untitled, 2015

Untitled, 2015

Cally Spooner

Damning Evidence Illicit Behaviour Seemingly Insurmountable Great Sadness Terminated In Any Manner (2014) is a work that the artist describes as being 'made from opera singers, YouTube comments and an opera surtitler' – an LED message display that helps the audience to follow an opera's narrative. In *Damning Evidence...* the surtitler is programmed with a libretto arranged by Spooner from YouTube comments logged by fans responding to footage of public heroes outsourcing their live performances to technology. The responses to these moments of delegation – which include Beyoncé resorting to lip-syncing at the 2013 presidential inauguration, and Lance Armstrong 'technically enhancing' his cycling, then apologising for it on *Oprah* – become hysterical six-minute operas delivered once a week by a melodramatic soprano, who sings directly from the surtitles. The singer's rhythm and pace is set by her own improvisations, which have been mechanised and programmed into the LED device.

Damning Evidence Illicit Behaviour Seemingly Insurmountable Great Sadness Terminated In Any Manner, 2014

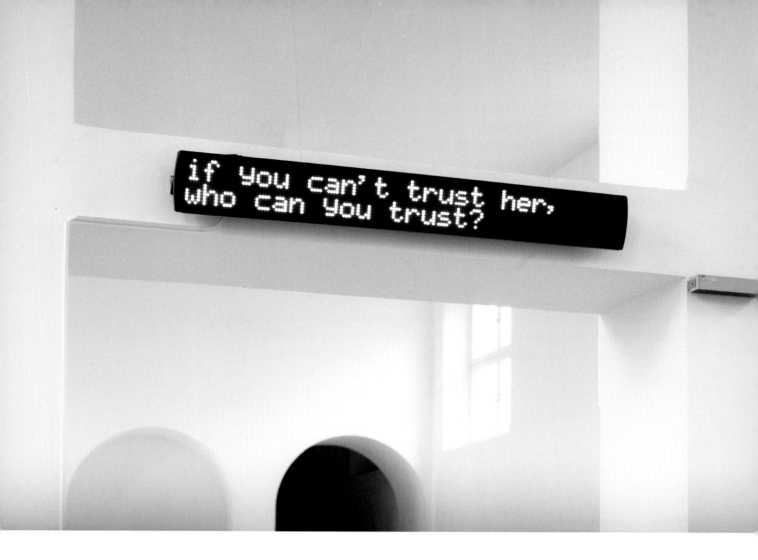

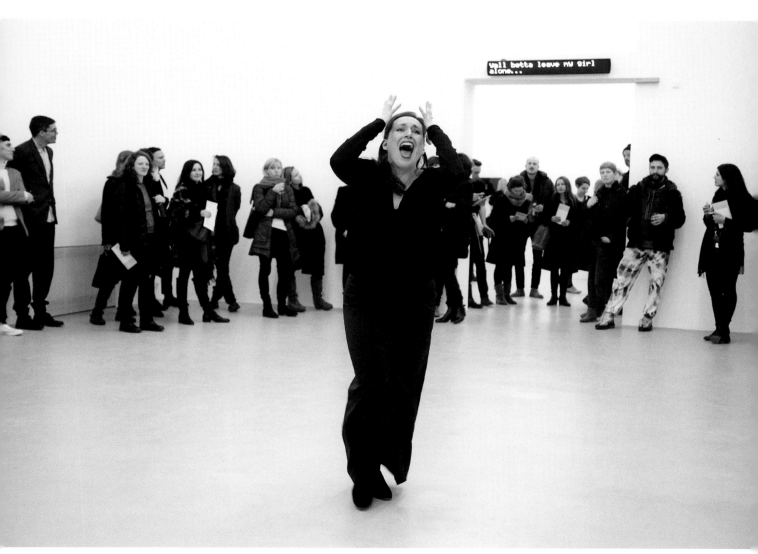

Patrick Staff

"I first visited the Tom of Finland Foundation in 2012, on a friend's recommendation. [...] Spending time there, I learnt how the house had been bought and set up as an intentional community of gay leather men in the 1970s. They hosted Tom of Finland (Finnish artist Touko Laaksonen, 1920-91) in the latter part of his life spent in Los Angeles, and in the 1980s formalised themselves to preserve his vast catalogue of homoerotic art, whilst endeavouring to 'educate the public to the cultural merits of erotic art and in promoting healthier, more tolerant attitudes about sexuality'.

"I was immediately sensitive in that house to thinking about the nature of intergenerational queer relationships; the relationship between gender, inheritance and cultural memory; and perhaps, most of all, of care: care for the individual's body, for a body of work, for the literal bodies of a community. I wasn't interested in making a work about that place, the people or Tom himself, but began to try to formulate something made *with* all of them. Over time, it became increasingly about understanding my own queer, transgender identity and about interrogating the body as a living, political archive."

From 'Roundtable on Social Relations', p.93

The Foundation, 2015 (film stills)

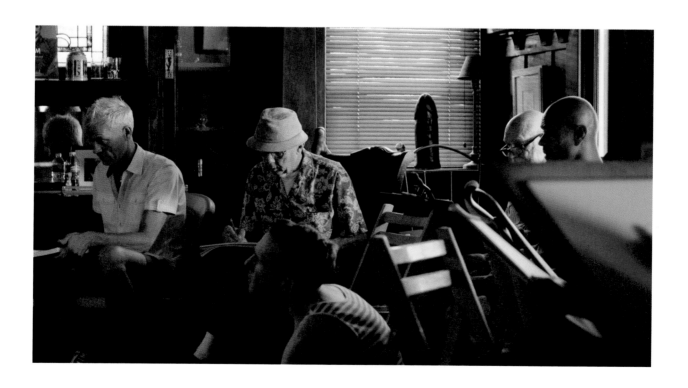

111

Imogen Stidworthy

Imogen Stidworthy's four-part video installation, *A Crack in the Light*
(2013), draws on narratives and materials related to a Soviet prison
in which speech analysis and surveillance research was conducted
by inmates during the 1940s and 1950s. One of these prisoners
was the Russian dissident Alexander Solzhenitsyn, who based his novel
The First Circle (1968) on these experiences. The installation includes
passages from the novel voiced by his wife, Natalya, and the actor
Alexei Kolubkov. Folding together the historical and the contemporary,
fact and fiction, Stidworthy's installation traces connections between
technologies and mechanisms of control, the act of listening and
the power of the voice.

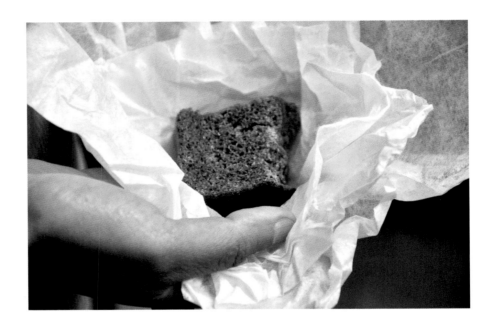

A piece of bread saved by Solzhenitsyn
from his last meal on Soviet soil,
in Lefortovo Prison, Moscow, 1974

A Crack in the Light, 2013 (film still)

113

A Crack in the Light, 2013
(installation view: Bergen Triennale, 2013)

A Crack in the Light, 2013 (film still)

Hayley Tompkins

Hayley Tompkins' floor and wall-based works often feature objects
that come into contact with the body and, in particular, the hand:
a mobile phone, a plastic water bottle, a section of a shirtsleeve
from elbow to cuff. Applying paint to the surfaces of these objects
– whether by brushwork, pouring or other means – Tompkins makes
familiar things strange. To the artist, these abstract works are
'almost figurative'. They provide an intimate but glancing portrait
of the way an individual looks at, thinks about and inhabits the world.

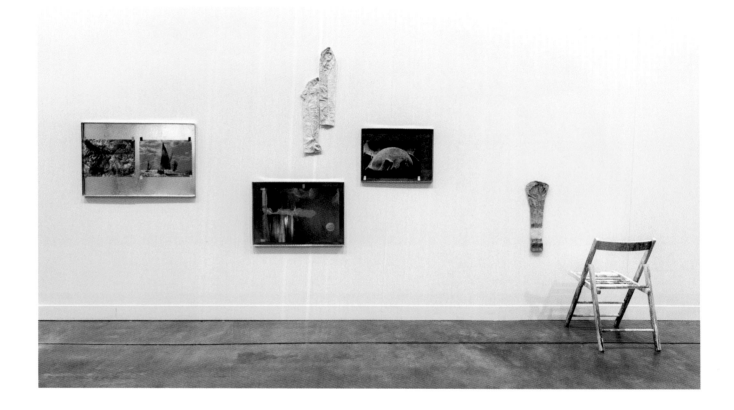

Installation view: MiArt, Milan, 2015

(top) *Vacation III*, 2015
(bottom) *Stick*, 2015

No Title, 2015

No Title, 2015

No Title, 2015

115

Jessica Warboys

"*Sea Paintings* are made below the high-water line at the sea's
edge. After immersion, the sodden canvases are pulled from the
sea and stretched out onto the beach. Mineral pigments are thrown
directly onto the sea-beaten canvas, its folds and creases catching
the grains of colour. The process is repeated with the canvas
returning to the sea or being left to dry.

"Wind, sand and folds create forms through the movement
of colours directed onto the canvas surface.

"The place and date of making is given in the title, emphasising
the mirroring of the location and time.

<div align="center">

Indexical
folds
sea sand wind
hand
gesture
pigment

</div>

"Hung or suspended, engulfing or opening into the space, the
canvases are not stretched, but retain the freedom to respond
to the architecture in which they are installed, maintaining
a continuous and open-ended approach to their interpretation.
The paintings' orientation and proportions can be adapted
as the canvases are positioned.

"This approach to painting relates to both performance and
gestural improvisation, and is parallel to the way I make films,
in which narrative is gradually revealed. In a material sense
the lengths of painted canvas could be interpreted as analogue
film; the sea painting pigment image could be seen to relate
to gesture as the grain of film relates to light and time."

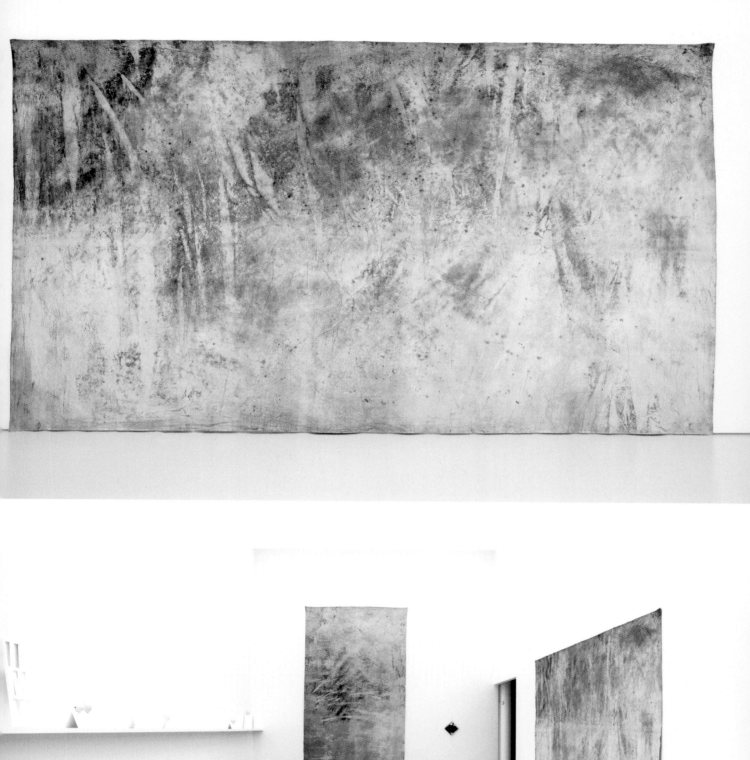

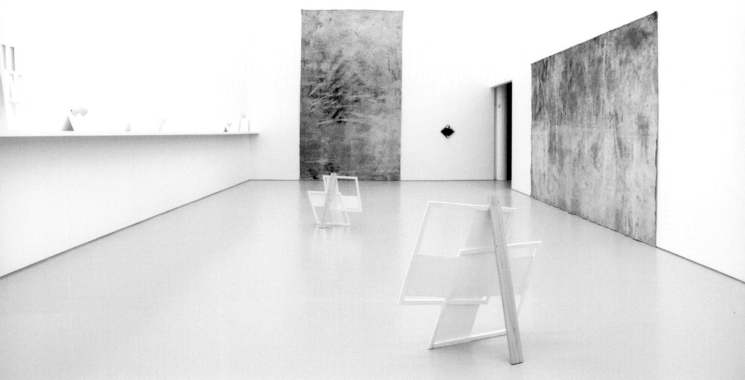

Sea Painting, Ab Ovo, Dunwich, 2013
(installation view: Spike Island, Bristol, 2013)

Ab Ovo, 2013
(installation view: Spike Island, Bristol, 2013)

117

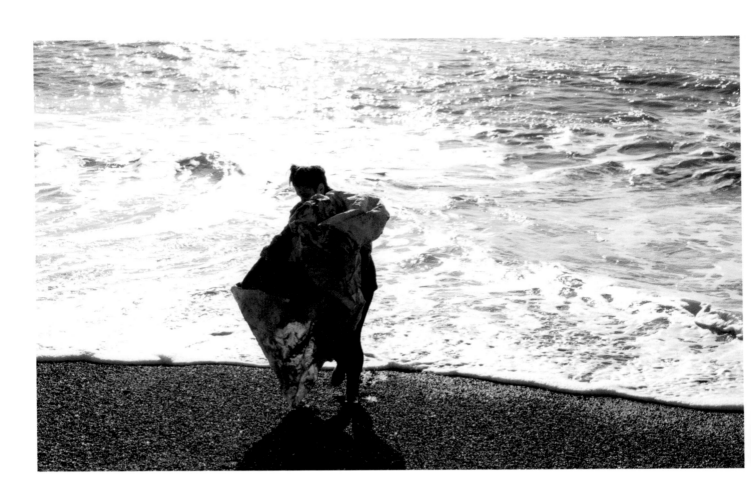

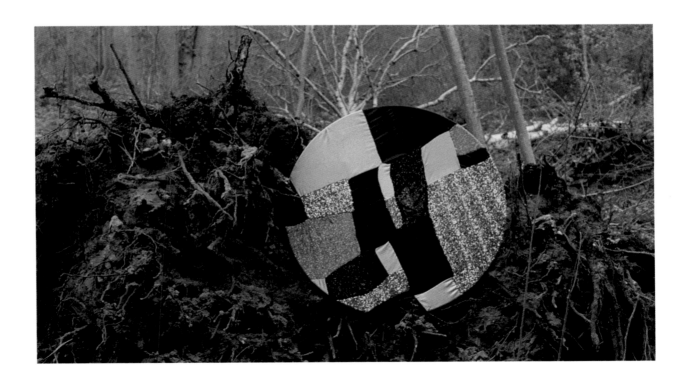

Production image, 2015
Boudica, 2014 (film still)

Sea Painting, July, Dunwich, 2015

Stuart Whipps

"*The Kipper and the Corpse* (2015) represents the third chapter in a series of works that I made at or in connection to Longbridge, the iconic site of motor manufacturing in Birmingham, UK.

"Between 2005 and 2008 I comprehensively photographed the Longbridge motor works following the closure of the plant and the loss of 6,500 jobs. MG Rover, which ceased trading with the closure, was the last large-volume British-owned car manufacturer. After the closure of Longbridge the intellectual property rights, the tooling and tracks were purchased from the site by the Chinese carmaker Nanjing Automotive. In 2007 I travelled to the new factory in Nanjing to document the site, the workers and the first cars coming off the production line.

"The second chapter was exhibited as part of East International in Norwich in 2009 and presented three of the aforementioned photographs alongside archival material and an analysis of Margaret Thatcher's speeches, interviews and statements from 1979. This work was the joint recipient of the East International Award. *The Kipper and the Corpse* revisits this period.

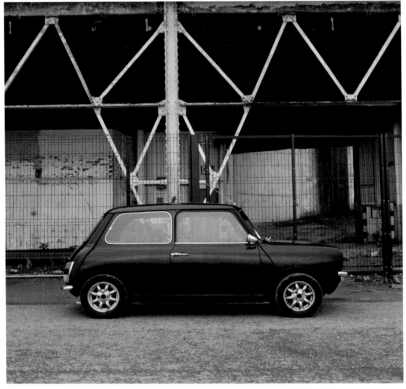

"1979 was a pivotal time in the UK generally and specifically at Longbridge. It saw the election of Margaret Thatcher in May and, at Longbridge, the sacking of the talismanic communist union convener Derrick (Red Robbo) Robinson in November.

"For *British Art Show 8* I purchased a 1275 GT Mini that was made at the Longbridge plant in 1979. I will be working with ex-employees of the factory to restore this car during the full run of the show, looking for evidence of the aforementioned tumult in its materials as it is stripped and rebuilt. As the work progresses various elements will be exhibited at different venues with the fully restored car being exhibited at Southampton in 2016/17."

1979 1275 GT Mini photographed at Longbridge, 2014

A found photograph of the Longbridge motor works as seen from Lannacombe Rd and a copy of *The Complete Fawlty Towers Scripts*, opened on *The Kipper and the Corpse*, first broadcast in 1979

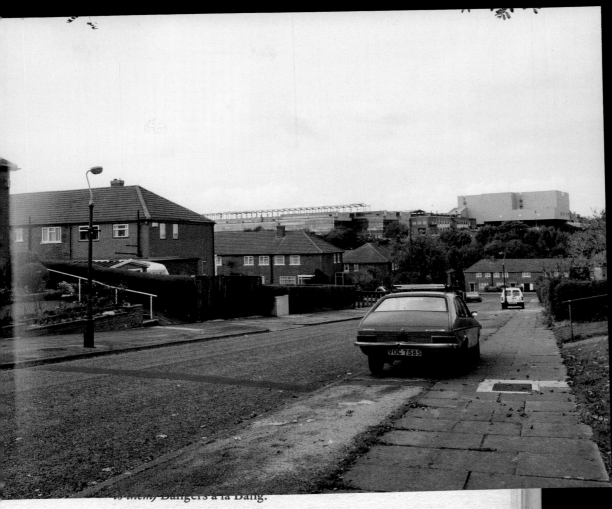

to them) Bangers à la Bang.

The upstairs corridor. Basil comes along with the tray, looking at the paper as he goes. He arrives at Mr Leeman's door and knocks.

Basil　　　Good morning! Breakfast!

Inside the room Mr Leeman is sitting up in bed, his eyes open. He is dead. The room light is on. Outside, Basil knocks again.

Basil　　　Breakfast! *(he opens the door and goes in; he puts the tray down in front of Mr Leeman)* Here we are. *(he picks up a book from the floor; Mr Leeman slumps forward and appears to be staring at the newspaper; Basil puts the book down on the bedside table)* Another car strike. Marvellous, isn't it. *(goes to the window and draws the curtains)* Taxpayers pay 'em millions each year, they get the money, go on strike. It's called Socialism. I mean if they don't like making cars why don't they get themselves another bloody job designing cathedrals or composing viola concertos? The British Leyland Concerto in four movements, all of 'em slow, with a four-hour tea break in between. I'll tell you why, 'cos they're not interested in anything except lounging about on conveyor belts stuffing themselves with

Interior details of 1979 1275 GT Mini
photographed at Longbridge, 2014

Bedwyr Williams

In *Century Egg* (2015) Bedwyr Williams speculates about what
conclusions archeologists of the future might draw from
the material remains of a single unremarkable drinks party.
The narrator's flights of fancy are accompanied by animations,
in which historic objects and artefacts from the collections
of the Cambridge Consortium of Museums – including skeletons,
classical statuary and suits of armour – are the main protagonists.

Century Egg, 2015 (production image)
Century Egg, 2015 (film still) 125 Century Egg, 2015 (film stills)

Jesse Wine

Jesse Wine's wall-based works of glazed ceramic tiles are described by the artist as paintings. The subject matter of *Still. Life.* (2015) is typical of his recent self-reflective preoccupations, drawing on quotidian occurrences and objects that infiltrate his daily existence. In *Still. Life.* the artist's studio mug of choice from the omnipresent British store sportsdirect.com infiltrates a Giorgio Morandi still life. His appropriation of art-historical high culture is a tongue-in-cheek expression of admiration, also in evidence in *The whole vibe of everything* (2015) which references ornate Japanese gilded panels, creating an exaggerated archetype of the craftsmanship he reveres.

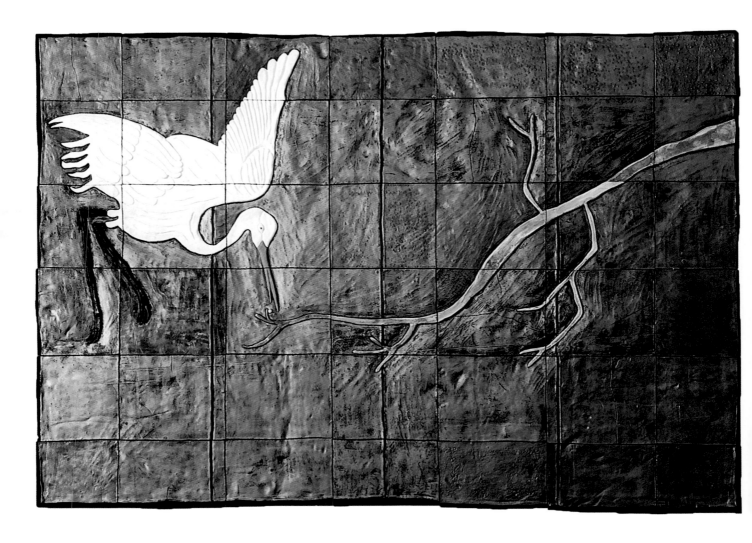

The whole vibe of everything, 2015

Still. Life., 2015

127

Lynette Yiadom-Boakye

The figures in Lynette Yiadom-Boakye's paintings are not real people,
but composites drawn from the artist's memory and imagination.
She likes to work quickly, with each painting usually completed within
the course of a day. Rather than aiming for formal perfection,
she hopes to 'make people intelligible through paint'.

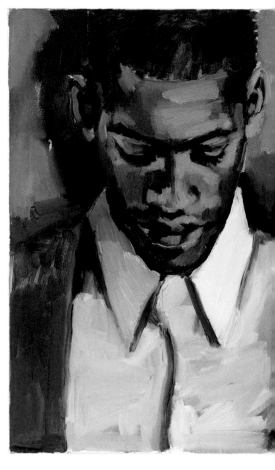

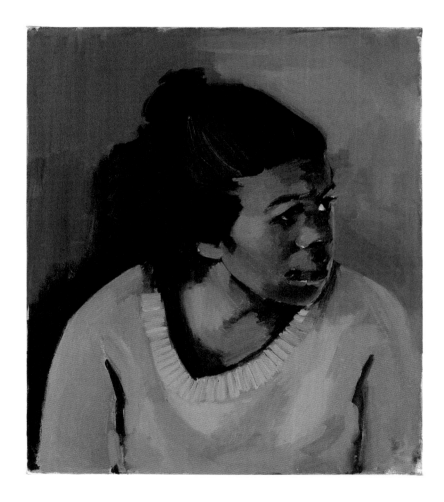

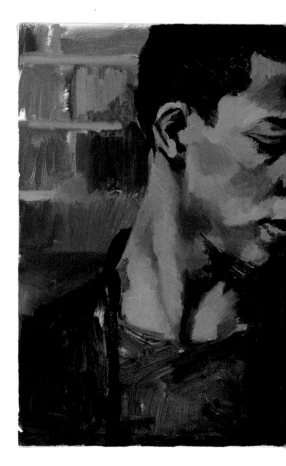

(clockwise from above)
The Hours And The Verses, 2015
Come Hither Through Heather, 2015
Wrought Iron, 2015

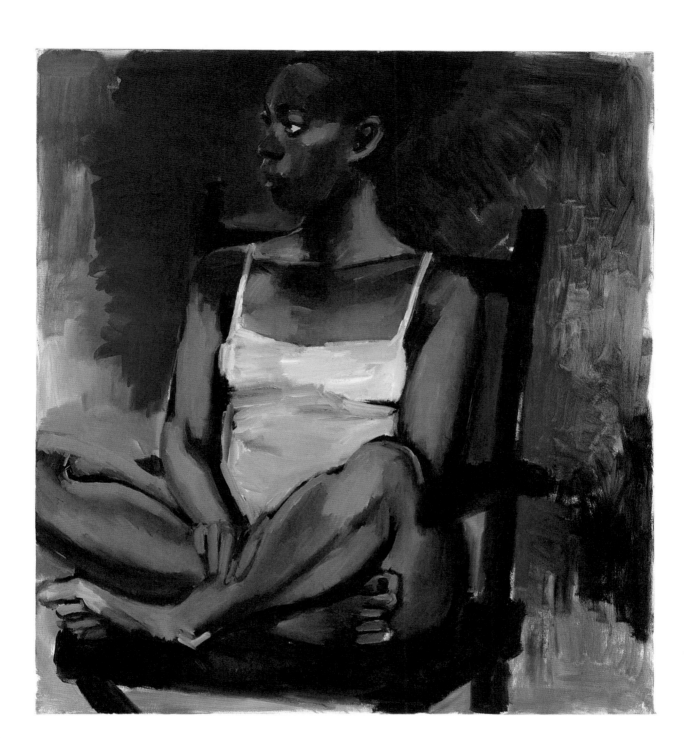

A Head For Botany, 2015

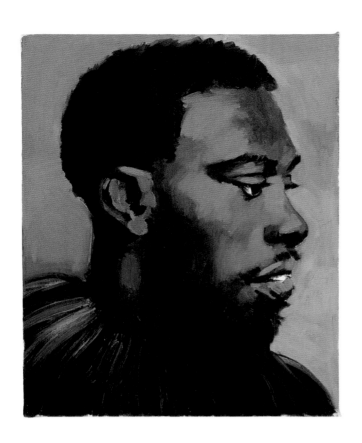

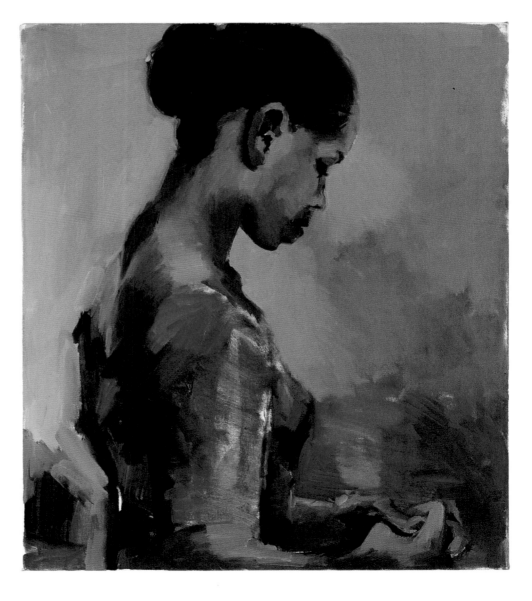

Lapwing Over Lark, 2015 The Twice Done, 2015

The Work, 2015 A Radical Under Beechwood, 2015

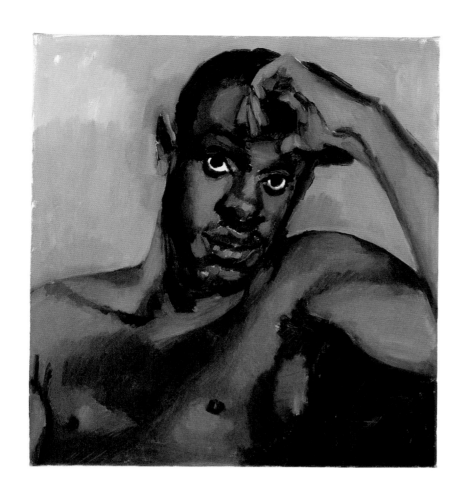

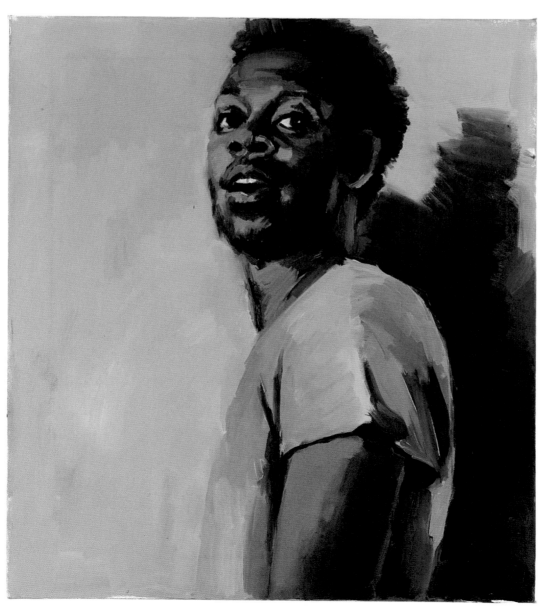

List of Works

Measurements are given in centimetres, height × width × depth

Not all works may be shown in all venues and details of newly created works are subject to change

Åbäke

Established 2000. Based in London

Fatima
2015
Wax, metal, chair, small furniture, book and small objects
120 × 60 × 75
Courtesy the artist

Lawrence Abu Hamdan

Born 1985 Amman, Jordan.
Lives and works London

A Convention of Tiny Movements
2015
Audio, tissue box and print
Dimensions variable
Courtesy the artist

Caroline Achaintre

Born 1969 Toulouse, France.
Lives and works London

Mother George
2015
Hand-tufted wool
280 × 185
Courtesy the artist
and Arcade, London

Om Nom Ore
2015
Hand-tufted wool
280 × 200
Courtesy the artist
and Arcade, London

Peter P
2014
Ceramic
52 × 38 × 10
Private collection, New York

Skwash
2014
Ceramic
50 × 40 × 14
Louise Clarke Collection, London

Todo Custo
2015
Hand-tufted wool
300 × 210
Courtesy the artist
and Arcade, London

John Akomfrah
& Trevor Mathison

Born 1957 Accra, Ghana.
Born 1960 London.
Both live and work London

All That Is Solid Melts Into Air
2015
Digital film
Courtesy the artists
and Smoking Dog Films, London

Aaron Angell

Born 1987 Kent.
Lives and works London

Bottle Kiln – Receiver
2015
Glazed stoneware
30 × 30 × 52
Courtesy the artist,
Rob Tufnell, London,
and Studio Voltaire, London

Dalmatian Spoon & Three Torcs
2015
Glazed stoneware
40 × 35 × 26
Courtesy the artist,
Rob Tufnell, London,
and Studio Voltaire, London

It is ten cloth yards in length
2014
Painted glass
90 × 70
Courtesy the artist,
Rob Tufnell, London,
and Studio Voltaire, London

Peach – Portcullis
2015
Painted glass
140 × 115
Courtesy the artist,
Rob Tufnell, London,
and Studio Voltaire, London

Tortoise, Candle Holder Variations – Nepenthes
2015
Lead-glazed earthenware
44 × 24 × 26
Courtesy the artist,
Rob Tufnell, London,
and Studio Voltaire, London

Untitled
2015
Glazed stoneware
32 × 32 × 24
Courtesy the artist,
Rob Tufnell, London,
and Studio Voltaire, London

Pablo Bronstein

Born 1977 Buenos Aires, Argentina.
Lives and works London and Kent

The Birth of the Skyscraper from Botanical Architecture
2015
Ink and watercolour
on paper in artist's frame
150 × 250
Courtesy the artist
and Herald St, London

Adam Broomberg
& Oliver Chanarin

Born 1970 Johannesburg,
South Africa, and 1971 London.
Both live and work London

Every piece of dust on Freud's couch
2015
Unique jacquard woven tapestry
290 × 200
Slide projector, 35mm slides
Courtesy the artists
and Lisson Gallery, London

Commissioned by
The Freud Museum, London

Dodo
2014
Propellor, HD film, archaeological materials, fibre-based prints
Dimensions variable
Courtesy the artists
and Lisson Gallery, London

This work will only be exhibited
in *British Art Show 8* in Edinburgh

Andrea Büttner

Born 1972 Stuttgart, Germany.
Lives and works London
and Frankfurt am Main

Images in Kant's Critique of the Power of Judgment
2014
11 offset prints on paper
177 × 120 each
Courtesy the artist, Hollybush
Gardens, London, and David
Kordansky Gallery, Los Angeles

Alexandre da Cunha

Born 1969 Rio de Janeiro, Brazil.
Lives and works London

Fatigue (diagram I)
2014
Metal, cement fondue
200 × 200 × 43
Courtesy the artist
and CRG Gallery, New York

Kentucky
2010
Woven mop heads and metal fixings
240 × 200 × 19
Monsoon Art Collection

Nicolas Deshayes

Born 1983 Nancy, France.
Lives and works London

Becoming Soil
2015
Welded steel, enamel
2 parts: 180 × 14 diameter
Courtesy the artist
and Jonathan Viner Gallery, London

Becoming Soil
2015
Welded steel, enamel
2 parts: 160 × 28.5 diameter plus
flat part and 180 × 20 diameter
Courtesy the artist
and Jonathan Viner Gallery, London

Becoming Soil
2015
Welded steel, enamel
3 parts: 200 × 29.5 diameter
plus flat part and two pipes
180 × 14 diameter each
Courtesy the artist
and Jonathan Viner Gallery, London

Cramps
2015
Vacuum-formed plastic,
pigmented polyurethane foam
and powder-coated aluminium
124.7 × 185.5 × 10
Courtesy the artist
and Jonathan Viner Gallery, London

Cramps
2015
Vacuum-formed plastic,
pigmented polyurethane foam
and powder-coated aluminium
124.7 × 185.5 × 10
Courtesy the artist
and Jonathan Viner Gallery, London

Cramps
2015
Vacuum-formed plastic,
pigmented polyurethane foam
and powdercoated aluminium
124.7 × 185.5 × 10
Courtesy the artist
and Jonathan Viner Gallery, London

Vein Section (or a cave painting)
2015
Vitreous enamel on steel,
powder-coated aluminium frame
30 × 150 × 5
Courtesy the artist
and Jonathan Viner Gallery, London

Vein Section (or a cave painting)
2015
Vitreous enamel on steel,
powder-coated aluminium frame
30 × 150 × 5
Courtesy the artist
and Jonathan Viner Gallery, London

Vein Section (or a cave painting)
2015
Vitreous enamel on steel,
powder-coated aluminium frame
30 × 150 × 5
Courtesy the artist
and Jonathan Viner Gallery, London

Vein Section (or a cave painting)
2015
Vitreous enamel on steel,
powder-coated aluminium frame
30 × 150 × 5
Courtesy the artist
and Jonathan Viner Gallery, London

Vein Section (or a cave painting)
2015
Vitreous enamel on steel,
powder-coated aluminium frame
30 × 150 × 5
Courtesy the artist
and Jonathan Viner Gallery, London

Vein Section (or a cave painting)
2015
Vitreous enamel on steel,
powder-coated aluminium frame
30 × 150 × 5
Courtesy the artist
and Jonathan Viner Gallery, London

Vein Section (or a cave painting)
2015
Vitreous enamel on steel,
powder-coated aluminium frame
30 × 150 × 5
Courtesy the artist
and Jonathan Viner Gallery, London

Vein Section (or a cave painting)
2015
Vitreous enamel on steel,
powder-coated aluminium frame
30 × 150 × 5
Courtesy the artist
and Jonathan Viner Gallery, London

Benedict Drew

Born 1977 Australia.
Lives and works Whitstable, Kent

Sequencer
2015
Installation
Dimensions variable
Courtesy the artist
and Matt's Gallery, London

Simon Fujiwara

Born 1982 London.
Lives and works Berlin, Germany

Fabulous Beasts (Chequered Fox)
2015
Shaved fur coat
140 × 100 × 2
Courtesy the artist

Fabulous Beasts (Deep Blue Mink)
2015
Shaved fur coat
175 × 110 × 2
Courtesy the artist

Fabulous Beasts (Desert Hide)
2015
Shaved fur coat
120 × 75 × 2
Courtesy the artist

Hello
2015
Digital film
10 minutes 15 seconds
Courtesy the artist

Martino Gamper

Born 1971 Merano, Italy.
Lives and works London

Post Forma
2015
Interactive installation
Dimensions variable
Courtesy the artist

Post Forma has been commissioned
by Yorkshire Festival and Hayward
Touring, in partnership with
Yorkshire Sculpture Triangle
and Arts Council England's
Strategic Touring Programme

Ryan Gander

Born 1976 Chester. Lives
and works London and Suffolk

*The cold was as three-dimensional
as the studio (Cable tie hat)*
2015
Wallpaper
Dimensions variable
Courtesy the artist
and Lisson Gallery, London

*The cold was as three-dimensional
as the studio (Full sized Aston)*
2015
Wallpaper
Dimensions variable
Courtesy the artist
and Lisson Gallery, London

*The cold was as three-dimensional
as the studio (Prayer beads)*
2015
Wallpaper
Dimensions variable
Courtesy the artist
and Lisson Gallery, London

*The cold was as three-dimensional
as the studio (Write some poetry)*
2015
Wallpaper pasted directly onto wall
Dimensions variable
Courtesy the artist
and Lisson Gallery, London

*A flawed and wounded man
bleeding frames onto a page*
2014
Video
59 minutes 28 seconds
Courtesy the artist
and Lisson Gallery, London

*Pushed into a corner by the logic
of my own making – Obscene Stereo*
2012
Two sheets of Perspex framed
in a white, wooden frame
105.7 × 85.7 × 3.5
Courtesy the artist
and gb agency, Paris

*Pushed into a corner by the logic
of my own making – Spray Paint*
2012
Two sheets of Perspex framed
in a white, wooden frame
105.7 × 85.7 × 3.5
Courtesy the artist
and gb agency, Paris

*Pushed into a corner by the logic
of my own making – Vajazzles*
2013
Two sheets of Perspex framed
in a white, wooden frame
105.7 × 85.7 × 3.5
Courtesy the artist
and Lisson Gallery, London

*The way things collide (Draughtsman's
paper weight, meet ice cream tub)*
2014
Lime-wood wood sculpture
30.8 × 22.8 × 32.1
Courtesy the artist
and gb agency, Paris

*The way things collide
(Picture crate, meet museau)*
2012
Carved wood
80.5 × 70.5 × 20.7
Courtesy the artist
and Lisson Gallery, London

*The way things collide (Toyota Prius
driver's seat, meet tampon)*
2014
Cherry-wood
71 × 37 × 66.5
Courtesy the artist
and gb agency, Paris

Melanie Gilligan

Born 1979 Toronto, Canada. Lives
and works London and New York

The Common Sense: Phase 1
2014–15
HD-video installation
5 episodes, each video 5–6 minutes
Courtesy the artist
and Galerie Max Mayer, Dusseldorf

Anthea Hamilton

Born 1978 London.
Lives and works London

Ant Farms
2015
Perspex, digital print
on PVC wallpaper, live ants,
PVC tubing, MDF
Dimensions variable
Courtesy the artist

Will Holder

Born 1969 Hatfield, Hertfordshire.
Lives and works Glasgow

*Our Values Make Us Different:
Non-diegetic Hum, Non-diegetic
Exclamation, Non-diegetic Hiss,
Non-diegetic Laughter.*
2015–16
Four works by female artists
from 1924–2015, wall drawing, talk
Courtesy the artist

Alan Kane

Born 1961 Nottingham.
Lives and works London
and Great Yarmouth, Norfolk

The But.
2015
Gravestone and metal base
Dimensions variable
Courtesy the artist
and Bruce Haines, Mayfair

The But..
2015
Hessian doormat
Dimensions variable
Courtesy the artist
and Bruce Haines, Mayfair

Mikhail Karikis

Born 1975 Thessaloniki, Greece.
Lives and works London

Children of Unquiet
2013–14
Video installation
15 minutes
Courtesy the artist

Linder

Born 1954 Liverpool.
Lives and works England

Diagrams of Love: Marriage of Eyes
2015
Gun-tufted rug
220 diameter
Courtesy the artist,
Stuart Shave / Modern Art
and Dovecot Studios Ltd

Children of the Mantic Stain
2015
Ballet
42 minutes
Courtesy the artist

Generously supported by Northern
Ballet and Dovecot Studios.
Choreography by Kenneth Tindall,
costume design by Christopher
Shannon, score by Maxwell Sterling

Rachel Maclean

Born 1987 Edinburgh.
Lives and works Glasgow

Feed Me
2015
HD video
Courtesy the artist and
Film and Video Umbrella (FVU)

Commissioned by Film and Video
Umbrella (FVU) and Hayward
Touring. Supported by Arts Council
England and Creative Scotland

Ahmet Öğüt

Born 1981 Diyarbakir, Turkey.
Lives and works Istanbul,
Amsterdam and Berlin

Ahmet Öğüt with Liam Gillick,
Susan Hiller and Goshka Macuga
Day After Debt (UK)
2015
A long-term counter-finance
strategy in collaboration
with Jubilee Debt Campaign
Courtesy the artist

Co-commissioned by Create
and Lafayette Anticipation – Fonds
de dotation Famille Moulin, Paris

Liam Gillick
Lazzarato on Debt
2015
Painted and printed steel
150 × 60
Courtesy the artist
and Maureen Paley, London

Susan Hiller
Thanks for Listening
2015
Jukebox with 70 songs
140 × 80 × 50
Courtesy the artist
and Lisson Gallery, London

Goshka Macuga
In Debt View
2015
Modified telescope
155 × 40 × 55
Courtesy the artist

Yuri Pattison

Born 1986 Dublin.
Lives and works London

The Ideal
2015
Installation, sculpture, video
Dimensions variable, within
180 × 300 × 220. Duration variable
Courtesy the artist and mother's
tankstation, Dublin

Ciara Phillips

Born 1976 Ottawa, Canada.
Lives and works Glasgow

Warm friends
2015
Framed screenprint on paper
Dimensions variable
Courtesy the artist

Cold cash
2015
Framed screenprint on paper
Dimensions variable
Courtesy the artist

Consider it a valid job
2015
Screenprint on linen
Dimensions variable
Courtesy the artist

No title
2015
Screenprint on newsprint
Dimensions variable
Courtesy the artist

Charlotte Prodger

Born 1974 Bournemouth, Dorset.
Lives and works Glasgow

Northern Dancer
2014
Audio and video installation
8 minutes
Courtesy the artist
and Koppe Astner, Glasgow

Commissioned by The Block

Charlotte Prodger would like to
thank Casey O'Connell, Luke Collins,
Isla Leaver-Yap, Matt Fitts,
Adam Milburn, Chelsea Space,
Maeve Redmond, Chris McCormack
and Richard Bevan.

Laure Prouvost

Born 1978 Lille, France.
Lives and works London

Hard Drive
2015
Audiovisual installation
5 minutes
Courtesy the artist
and MOT International,
London and Brussels

Magali Reus

Born 1981 The Hague,
The Netherlands.
Lives and works London

Leaves (Aspen Grey, March)
2015
Polyester resin, filler, phosphated
aluminium tube, silicone rubber,
pigments, powder-coated,
zinc-plated and anodised, laser-cut
aluminium and steel, bolts
46.5 × 18.5 × 58
Courtesy the artist
and The Approach, London

Leaves (Cole Raven, October)
2015
Milled and sprayed model board,
jesmonite, polyester resin, filler,
phosphated aluminium tube,
silicone rubber, pigments, powder-
coated, zinc-plated, sand-blasted,
phopsphated, anodised and etched
laser-cut aluminium and steel,
acrylic
38.5 × 9.7 × 44
Courtesy the artist
and The Approach, London

Leaves (Jet, December)
2015
Jesmonite, aggregate, wax,
filler, phosphated aluminium tube,
silicone rubber, pigments,
powder-coated, zinc-plated,
anodised and etched laser-cut
aluminium and steel, bolts
45 × 17.5 × 53
Courtesy the artist
and The Approach, London

Leaves (Kent Stripes, June)
2015
Milled model board, jesmonite,
aggregates, carbon fibre,
polyester resin, wax, phosphated
aluminium tube, silicone rubber,
pigments, powder-coated and
anodised, laser-cut aluminium
and steel, brass, acrylic
40 × 10 × 51.4
Courtesy the artist
and The Approach, London

Leaves (Skip, February)
2015
Milled model board, jesmonite,
aggregate, wax, phosphated
aluminium tube, silicone rubber,
pigments, powder-coated,
anodised, and blackened laser-cut
aluminium and steel, brass
41 × 17 × 53.5
Courtesy the artist
and The Approach, London

Generously supported by the
Mondriaan Fund and the Embassy
of the Kingdom of the Netherlands

James Richards

Born 1983 Cardiff.
Lives and works London and Berlin

Raking Light
2014
Digital video with sound
7 minutes 5 seconds
Courtesy the artist
and Cabinet, London

Raking Light was co-produced
by the Centre d'Art Contemporain
Genève, Geneva, for the BIM 14,
with the support of FMAC,
FCAC and MONA Museum

Eileen Simpson
& Ben White

Both born 1977 Manchester.
Live and work London

Auditory Learning
2015-16
Multi-part work
Dimensions variable
Courtesy the artists

Daniel Sinsel

Born 1976 Munich, Germany.
Lives and works London

Untitled
2015
Oil on linen
32.2 × 27.2 × 3.3
Courtesy Sadie Coles HQ, London

Untitled
2015
Oil on linen, coprolite, 9ct gold
42.7 × 37 × 4.5
Courtesy Sadie Coles HQ, London

Untitled
2015
Oil on linen, Herkimer diamond,
9ct gold wire
32 × 27 × 4
Courtesy Sadie Coles HQ, London

Untitled
2015
Watercolour on paper
60 × 80 × 10
Courtesy Sadie Coles HQ, London

Untitled
2015
Watercolour on paper
60 × 80 × 10
Courtesy Sadie Coles HQ, London

Untitled
2015
Oil on linen, antique animal tusk,
9ct gold wire
32 × 26 × 6
Courtesy Sadie Coles HQ, London

Untitled
2015
Oil on linen, coprolite, 9ct gold
32 × 28.5 × 5
Courtesy Sadie Coles HQ, London

Cally Spooner

Born 1983 Ascot, Berkshire.
Lives and works London

*Damning Evidence Illicit Behaviour
Seemingly Insurmountable Great
Sadness Terminated In Any Manner*
2014
Opera singers, opera surtitles,
YouTube comments
140 × 8 × 18; 6 minutes
Courtesy the artist

Originally commissioned by
Kunstverein München, Munich,
for the exhibition *La voix humaine*
(29 January – 30 March 2014)

At Leeds Art Gallery, *Damning
Evidence Illicit Behaviour Seemingly
Insurmountable Great Sadness
Terminated In Any Manner* will be
delivered at 14:00 every Saturday
(except 26 December 2015 and
2 January 2016). For information
about subsequent venues, please
check www.britishartshow8.com

Patrick Staff

Born 1987. Lives and works
London and Los Angeles

The Foundation
2015
Film installation
30 minutes
Courtesy the artist

Commissioned by Chisenhale
Gallery, London; Spike Island,
Bristol; Institute of Modern Art,
Brisbane; and Contemporary Art
Gallery, Vancouver. Co-produced
by Chisenhale Gallery, London;
and Spike Island, Bristol

Imogen Stidworthy

Born 1963 London.
Lives and works Liverpool

A Crack in the Light
2013–14
Film installation
10 minutes 33 seconds
Courtesy the artist
and Matt's Gallery, London

Hayley Tompkins

Born 1971 Leighton Buzzard,
Bedfordshire.
Lives and works Glasgow

Digital Light Pool XCVII
2015
Acrylic paint on plastic
35 × 48 × 5
Courtesy the artist
and The Modern Institute/
Toby Webster Ltd, Glasgow

Digital Light Pool XCVIII
2015
Acrylic paint on plastic
35 × 48 × 5
Courtesy the artist
and The Modern Institute/
Toby Webster Ltd, Glasgow

Digital Light Pool XCIX
2015
Acrylic paint on plastic
35 × 48 × 5
Courtesy the artist
and The Modern Institute/
Toby Webster Ltd, Glasgow

Digital Light Pool C
2015
Acrylic paint on plastic
35 × 48 × 5
Courtesy the artist
and The Modern Institute/
Toby Webster Ltd, Glasgow

Digital Light Pool CI
2015
Acrylic paint on plastic
22 × 31 × 5.5
Courtesy the artist
and The Modern Institute/
Toby Webster Ltd, Glasgow

Digital Light Pool CII
2015
Acrylic paint on plastic
22 × 31 × 5.5
Courtesy the artist
and The Modern Institute/
Toby Webster Ltd, Glasgow

Vacation III
2015
Acrylic paint on cotton
59 × 19 × 1.5
Courtesy the artist
and The Modern Institute/
Toby Webster Ltd, Glasgow

Stick
2015
Acrylic on found object
51 × 18 × 10
Courtesy the artist
and The Modern Institute/
Toby Webster Ltd, Glasgow

Jessica Warboys

Born 1977 Newport.
Lives and works Suffolk and Berlin

Sea Painting, July, Dunwich
2015
Mineral pigment, canvas
180 × 300
Courtesy the artist

A new painting will be made
at a corresponding coastal
point for each city throughout
the course of the exhibition.
More information can be found
at www.britishartshow8.com

Stuart Whipps

Born 1979 Birmingham.
Lives and works Birmingham

AMR 733V, Detail. 001
2015
Digital chromogenic print
150 × 125
Courtesy the artist

AMR 733V, Detail. 002
2015
Digital chromogenic print
150 × 125
Courtesy the artist

The Kipper and the Corpse
2015
1275 GT Mini
Dimensions variable
Courtesy the artist

Part of Longbridge Public
Art Project (LPAP) by WERK.
Generously supported by The
William A. Cadbury Charitable Trust

Bedwyr Williams

Born 1974 St Asaph, Denbighshire.
Lives and works Caernarfon,
Gwynedd

Century Egg
2015
HD video, fibreglass egg
30 minutes
Courtesy the artist
and Limoncello, London

Commissioned by University of
Cambridge as part of the North
West Cambridge Development,
in partnership with Contemporary
Art Society and InSite Arts

Jesse Wine

Born 1983 Chester, Cheshire.
Lives and works London

Still. Life.
2015
Glazed ceramic
191 × 265
Courtesy the artist
and Limoncello, London

The whole vibe of everything
2015
Glazed ceramic
171 × 241
Courtesy the artist
and Limoncello, London

Lynette Yiadom-Boakye

Born 1977 London.
Lives and works London

Come Hither Through Heather
2015
Oil on canvas
60.5 × 40 × 3.7
Courtesy Corvi-Mora, London, and
Jack Shainman Gallery, New York

A Head For Botany
2015
Oil on canvas
95 × 85 × 3.7
Courtesy Corvi-Mora, London and
Jack Shainman Gallery, New York

The Hours And The Verses
2015
Oil on canvas
65 × 55.5 × 3.7
Courtesy Corvi-Mora, London and
Jack Shainman Gallery, New York

Lapwing Over Lark
2015
Oil on canvas
50.5 × 40.5 × 3.7
Courtesy Corvi-Mora, London and
Jack Shainman Gallery, New York

A Radical Under Beechwood
2015
Oil on canvas
80 × 70 × 3.7
Courtesy Corvi-Mora, London and
Jack Shainman Gallery, New York

The Twice Done
2015
Oil on canvas
60.5 × 55.5 × 3.7
Courtesy Corvi-Mora, London and
Jack Shainman Gallery, New York

The Work
2015
Oil on canvas
70.5 × 60.5 × 3.7
Courtesy Corvi-Mora, London and
Jack Shainman Gallery, New York

Wrought Iron
2015
Oil on canvas
55.5 × 50.5 × 3.7
Courtesy Corvi-Mora, London and
Jack Shainman Gallery, New York

Copyright credits

Image credits

List of Illustrated Works
Not in Exhibition

Measurements are given in
centimetres, height × width × depth

Unknown photographer

*Heinrich Lomer's fur emporium
in Leipzig*
1905

Åbäke

*Slow Alphabet '4'
(British Art Show 8 catalogue)*
2015
Catalogue intervention
31.5 × 21
Courtesy the artist

Official Portrait
2012
Digital image
Courtesy the artist

Lawrence Abu Hamdan

A Convention of Tiny Movements
2015
Audiovisual installation
Dimensions variable
Courtesy the artist
and The Armory Show

Caroline Achaintre

L.O.C.K.
2015
Ink on paper
21 × 30
Courtesy the artist

Splitting Image
2015
Ink on paper
21 × 30
Courtesy the artist

Pablo Bronstein

Lowestoft Porcelain Factory
2015
Ink and watercolour
on paper in artist frame
64 × 78 × 7.5 cm
Courtesy the artist, Herald St,
London, and Franco Noero, Turin

Minton China Factory
2015
Installation view: The Museum
of Fine Arts, Houston, 2015
Ink and watercolor on paper
in artist's frame
Dimensions variable
Courtesy the artist
and Franco Noero, Turin

Worcester Porcelain Factory
2014–15
Ink and watercolour
on paper in artist frame
156 × 190 × 11
Courtesy the artist, Herald St,
London, and Franco Noero, Turin

Stan Canter

Mud Pot, Norris Geyser Basin
1967
Courtesy National Park Service
(NPS)

Nicolas Deshayes

Pipe Study
2014
Watercolour on inkjet print
Courtesy the artist

Pipe Study
2014
Watercolour on inkjet print
Courtesy the artist

P. L. Doclus

Coloured drawing of large
sea snail, soft parts protruding,
showing snout, eyestalks and
foot with claw-shaped operculum
1844

Martino Gamper

Hands On
2006
From the series
100 Chairs in 100 Days, 2005–07
Mixed media
35 × 51 × 85
Courtesy Åbäke
and Martino Gamper

Ryan Gander

*Pushed into a corner by the logic
of my own making – QSL Collection*
2012
C-Type print mounted
on Perspex, paint
85.7 × 10.57 × 35
Edition of 1
Courtesy the artist
and TARO NASU, Tokyo

*Pushed into a corner by the logic
of my own making – Leica M9*
2012
C-Type print mounted
on Perspex, paint
85.7 × 10.57 × 35
Edition of 1
Courtesy the artist
and TARO NASU, Tokyo

Anthea Hamilton

Karl Lagerfeld Bean Counter
2012
Digital image
Courtesy the artist

Manarch (Pasta)
2009
Digital image
Courtesy the artist

Will Holder

*[Hum] There is a world of
communication which is not dependent
on words. This is the world in which
the artist operates, and for him words
can be dangerous unless they are
examined in the light of the work.
The communication is in the work
and words are no substitute for this.
However, there is an idea that it is a
duty on the part of the artist to offer
up explanations of his work to the élite
who are in control of its interpretation
and promotion, and the necessity of
such an élite being as well-informed as
possible is certain. Mary Martin, 1968*
2015
Sketch for wall drawing,
adapted marker pen
Dimensions variable
Courtesy the artist

Alan Kane

Vanity Suite/Sorry
2015
Headstones, lacquered steel,
hair dryer
Dimensions variable
Courtesy the artist, DKUK
and Bruce Haines, London

The But.
2015
Digital preparatory image
Courtesy the artist and Bruce
Haines, Mayfair

Linder

Superautomatism Grand Jeté I
2015
Enamel on paper
28 × 21.5
Courtesy the artist

The Ultimate Form Ballet
2013
Dancers from Northern Ballet with
choreography by Kenneth Tindall
and costumes by Richard Nicoll
The Hepworth Wakefield, 2013
Courtesy the artist

Marlow Moss

Spatial Construction in Steel
1956–58
Steel
130 × 81 × 23
Courtesy Leeds Museums
and Galleries (Leeds Art Gallery)

Bought with the aid of grants
from The Art Fund, the MLA/V&A
Purchase Grant Fund
and the Leeds Art Fund, 2004

Yuri Pattison

*HaoBTC Bitcoin mine in Kangding,
Garzê Tibetan Autonomous Prefecture,
People's Republic of China*
2015
Still from video recorded by Eric
Mu, CMO of HaoBTC, for the artist

Courtesy the artist
and mother's tankstation, Dublin

*RELiable COMmunications
(http://reliablecommunications.net/)*
2013
Webpage (html, css,
javascript, php, jpeg, gif, png)

Courtesy the artist
and mother's tankstation, Dublin

Commissioned by Legion TV,
London, and co-presented
with the New Museum, New York

Ciara Phillips

Justice for Domestic
Workers printing in *Workshop*,
(2010–ongoing)
2013
Courtesy the artist

Ciara Phillips and Justice
for Domestic Workers
No 2 Slavery banner
2013
Screenprinted cotton
Courtesy the artist
and Justice for Domestic Workers

Commissioned by
The Showroom, London

Things Shared
2014
Installation view: Tate Britain,
London, 2014
Courtesy the artist

Laure Prouvost

The e-cigarette and the butter
2014
Butter, e-cigarette, programmed
light sequence, sound
Dimensions variable
Courtesy the artist and MOT
International, London and Brussels

Magali Reus

Leaves (Tricks, September)
2015
Milled and spray-painted model
board, phosphate aluminium tube,
polyurethane rubber, pigments,
powder-coated, zinc-plated,
anodised, phosphated and
blackened laser-cut aluminium
and steel, polyester resin
53 × 16 × 42
Courtesy the artist
and The Approach, London

Leaves (Dale Arches, June)
2015
Milled and spray-painted model
board, phosphated aluminium
tube, jesmonite, pigments, powder
coated, anodised, phosphated
and blackened laser-cut aluminium
and steel, polyester resin, Perspex
39 × 55 × 12
Courtesy the artist and
The Approach, London

Leaves (Peat, March)
2015
Milled and spray painted
model board, aluminium tube,
polyurethane rubber, powder
coated, anodised, phosphated
and blackened aluminium
and steel, brass, Perspex
37.5 × 11 × 46.5

J. Schmidt

*Close-up of Mud Pot,
West Thumb Geyser Basin*
1977
Courtesy National
Park Service (NPS)

Eileen Simpson
& Ben White

The Decibelles sing 1963 hit
'Be My Baby' by The Ronettes
VHS still
Institute of Sound and
Vibration Research (ISVR) party,
Southampton University, 1983
Courtesy Tony Lawther

Hayley Tompkins

No Title
2015
Gouache on paper
20 × 15.5
Courtesy the artist
and The Modern Institute/
Toby Webster Ltd, Glasgow

No Title
2015
Gouache on paper
20 × 15.5
Courtesy the artist
and The Modern Institute/
Toby Webster Ltd, Glasgow

No Title
2015
Gouache on paper
20 × 15.5
Courtesy the artist
and The Modern Institute/
Toby Webster Ltd, Glasgow

No Title
2015
Gouache on paper
20 × 15.5
Courtesy the artist
and The Modern Institute/
Toby Webster Ltd, Glasgow

Jessica Warboys

Sea Painting, Ab Ovo, Dunwich
2013
Mineral pigment, canvas
320 × 550
Courtesy the artist
and Gaudel de Stampa, Paris

Boudica
2014
35mm transfer to HD,
16:9, colour, sound
Camera: Ville Piippo, sound:
Morten Norbye Halvorsen,
assistant: Ieva Kabasinskaite
5 minutes 38 seconds
Courtesy the artist
and Gaudel de Stampa, Paris

Commissioned by
Arts Council England

Aldren A. Watson

*Hand Bookbinding:
A Manual of Instructions*
1963
Courtesy Bell Publishing
Company, Inc. New York

Author Biographies

Anna Colin is an independent curator based in London. She is a co-founder and Co-Director of Open School East, a space that brings together a free study programme for emerging artists and a creative learning programme open to all. Since 2014, she has also worked as Associate Curator at Fondation Galeries Lafayette in Paris. Colin has curated exhibitions and projects in spaces including the Whitechapel Gallery, London; Victoria Gallery & Museum, Liverpool; Le Quartier, contemporary art centre of Quimper; La Synagogue de Delme; la Maison populaire, Montreuil; Galleria d'Arte Moderna, Turin; CIC Cairo; and The Women's Library, London. From 2011–12 she was Co-Director of Bétonsalon, Paris, and 2007–10 was Curator at Gasworks, London.

Lydia Yee is Chief Curator at Whitechapel Gallery. She was previously Curator at Barbican Art Gallery, where her exhibitions included *Magnificent Obsessions: The Artist as Collector* (2015), *Bauhaus: Art as Life* (2013, co-curated with Catherine Ince), and *Laurie Anderson, Trisha Brown, Gordon Matta-Clark: Pioneers of the Downtown Scene* (2011). Previously Yee was Senior Curator at Bronx Museum of the Arts, New York, where she received the Emily Hall Tremaine Exhibition Award 2006 for *Street Art, Street Life*. In 2003, she was the Cassullo Fellow at the Whitney Museum of American Art Independent Study Program. She is a contributor to *artnet News* and has also written essays for exhibition catalogues and publications on artists including Susan Hiller, Gordon Matta-Clark, Martin Wong and others.

Janna Graham is a writer, organiser, educator and curator, currently Head of Public Programmes and Research at Nottingham Contemporary. Previously she founded The Centre for Possible Studies at Serpentine Gallery, London, and worked at institutions including Art Gallery of Ontario, Toronto; Whitechapel Gallery, London; Van Abbemuseum, Eindhoven; and Plymouth Art Centre, Plymouth.

François Quintin is a curator and writer, currently Director of Fondation Galeries Lafayette, Paris. Previously he was Director of FRAC Champagne-Ardennes.

Acknowledgements

An exhibition of this scale and complexity depends on the cooperation of many people, and we are especially fortunate to have received support for this *British Art Show* from numerous sources. In addition to our essential funding from Arts Council England, a special grant from its Strategic Touring Programme has enabled us to engage creatively with a wider public than ever before. We particularly appreciate the advice and encouragement of Arts Council England's Relationship Manager Daniel Cutmore, who helped to steer our initial thinking about the possibilities and will be overseeing the process of realising the programme of activities over the 16-month period of the tour. We would also like to thank Jo Baxendale of Arts Council England for her guidance on our application, which was prepared by Kath Wood, with Hayward Touring Assistant Curator Gilly Fox and Leeds Art Gallery Curator Sarah Brown. Our evaluator on this project is Annabel Jackson.

The following new commissions have been produced in collaboration with, or with financial assistance from, partner organisations:

Martino Gamper's project for Leeds, *Post Forma*, has been commissioned by Yorkshire Festival and Hayward Touring, in partnership with Yorkshire Sculpture Triangle (a consortium consisting of The Hepworth Wakefield, Yorkshire Sculpture Park, The Henry Moore Institute and Leeds Art Gallery, supported by Wakefield Council and Leeds City Council). *Post Forma* will also be presented at The Hepworth Wakefield and at Yorkshire Sculpture Park.

Ahmet Öğüt's, *Day After Debt (UK)*, with artists Liam Gillick, Susan Hiller and Goshka Macuga, in collaboration with Jubilee Debt Campaign, is co-commissioned by Create and Lafayette Anticipation – Fonds de dotation Famille Moulin, Paris. The contract, which constitutes an essential part of the artwork, was drawn up by Daniel McClean, Consultant, Art and Cultural Property Team at Howard Kennedy LLP. At Create, we thank Marijke Steedman, Curator, Hadrian Garrard, Director, and Razia Begum, Producer, who have been instrumental in developing the relationship with Jubilee Debt Campaign. At Lafayette Anticipation – Fonds de dotation Famille Moulin, we thank François Quintin, Director, Laurence Perrillat, Administrator, Gabrielle Jaegle, Administrative Assistant, and Dirk Meylaerts, Director of Production, who oversaw the production of Liam Gillick's piece *Lazzarato on Debt*. Susan Hiller's project was produced with the help of Nelson Beer, who sourced the music, and Jason Whittingham, Company Director at G&J Sales, who supplied the jukebox. Goshka Macuga's project was produced by Mark Fairman, Tourist Telescopes. At Jubilee Debt Campaign, we thank Jonathan Stevenson. The project has been managed by Hayward Gallery Assistant Curator, Eimear Martin.

Rachel Maclean's new film, *Feed Me*, is co-commissioned and produced by Film and Video Umbrella (FVU), and generously supported by Creative Scotland's Open Project Funding. Thanks to FVU: Steven Bode, Director; Susanna Chisholm, Operations Director; Ohna Falby, Production Manager; Alix Taylor, Production Officer; Joseph Field, Production Assistant; Mike Jones, Technical Manager; Victoria Norton, Communications Officer; Ilona Sagar, Team Assistant.

Linder's *Diagrams of Love: Marriage of Eyes* is a collaboration with Dovecot Tapestry Studio in Edinburgh, where her textile was made. This work will be activated in each city by a new ballet, *Children of the Mantic Stain*, choreographed by Kenneth Tindall and performed by Northern Ballet, with costumes by fashion designer Christopher Shannon and score by composer Maxwell Sterling. At Dovecot we thank: Jonathan Cleaver, Dennis Reinmueller, Vana Coleman, Naomi Robertson, Lizzie Cowan, Sandra Crow and David Weir for their dedication and support. At Northern Ballet we thank: David Nixon, Mark Skipper and dancers of Northern Ballet: Hannah Bateman, Giuliano Contadini, Jeremy Curnier, Nicola Gervasi, Jessica Morgan, Victoria Sibson and Matthew Topliss.

Stuart Whipps' project, *The Kipper and the Corpse*, is part of Longbridge Public Art Project (LPAP) by WERK and is generously supported by The William A. Cadbury Charitable Trust. Thanks to Claire Farrell, Stephen Burke and Sarah Nokes of WERK, and all of the workers involved in the restoration. Additional support was provided by Bromsgrove Engine Services. Photographs were produced with help from Spectrum Photographic and The Flash Centre.

We are grateful to The Henry Moore Foundation for its support of the exhibition.

Magali Reus' new works are made possible by a grant from the Mondriaan Fund. We thank Laia Frijhoff, Grants Officer. We are also grateful for support from the Embassy of the Kingdom of the Netherlands.

We are indebted to ArtAV for in-kind support, and particularly thank Tom Cullen for expertly managing the extensive and complex programme of audio-visual works and interventions in the exhibition.

Lenders to the exhibition: The Approach, London; Arcade, London; Cabinet, London; Corvi-Mora, London; CRG Gallery, New York; Dovecot Studios, Edinburgh; Film and Video Umbrella (FVU); gb agency, Paris; Herald St, London; Hollybush Gardens, London; Jonathan Viner Gallery, London; Koppe Astner, Glasgow; Limoncello, London; Lisson Gallery, London; Louise Clarke Collection, London; Matt's Gallery, London; Galerie Max Mayer, Dusseldorf; The Modern Institute/Toby Webster Ltd, Glasgow; Monsoon Art Collection, London; mother's tankstation, Dublin; MOT International, London and Brussels; Rob Tufnell, London; Sadie Coles HQ, London; Stuart Shave/Modern Art, London; Studio Voltaire, and others who wish to remain anonymous.

Artists' galleries: The Approach: Emma Robertson, Mary Cork and Malik Al-Mahrouky; Arcade: Christian Mooney; Cabinet: Andrew Wheatley and Freddie Checketts; Corvi-Mora: Tommaso Corvi-Mora, James Halliwell and Nick Skipp; CRG Gallery: Joe Ellis; Herald St: Nicky Verber and Naja Rantorp; Hollybush Gardens: Lisa Panting and Malin Ståhl; Koppe Astner; Jonathan Viner Gallery: Judith Neubauer; Limoncello: Grace Sherrington; Lisson Gallery: Andreas Leventis, Louise Hayward and Emma Gifford-Mead; Matt's Gallery: Robin Klassnik, Laura Hensser and Beth Bramich; Galerie Max Mayer: Max Mayer; The Modern Institute: Andrew Hamilton, Kath Roper-Caldbeck and Morven Roger; MOT International: Nicola Wright; Sadie Coles HQ: Pauline Daly and Brinda Roy; Thomas Dane Gallery: Tom Dingle.

Artists' studios: Åbäke studio: Charlotte York with designer Harry Thaler; John Akomfrah and Trevor Mathison (Smoking Dog Films): Lina Gopaul, Ashitey Akomfrah and David Lawson; Pablo Bronstein studio: Skyla Bridges; Broomberg & Chanarin studio: Lou Miller; Andrea Büttner studio: Alanna Gedgaudas; Simon Fujiwara studio: Maria Bartau; Martino Gamper studio: Gemma Holt; Ryan Gander studio: Holly Featherstone and Katherine Gardener; Anthea Hamilton studio: Lauren Godfrey; Laure Prouvost studio: Ciaran Wood with production by Sam Belinfante; Cally Spooner studio: Sophie Oxenbridge.

The *British Art Show 8* curators would like to thank the following individuals for help and advice: Bryony Bond; Ben Borthwick; Maolíosa Boyle; Sara Cluggish; Rosie Cooper; Clarissa Corfe; Claire Doherty; Graham Domke; Alex Farquharson; Hannah

Firth; Teresa Gleadowe; Sara Greavu; Andrew Hamilton; Louise Hutchinson; Flora Katz; Helen Legg; Francesco Manacorda; Sarah McCrory; Karen MacKinnon; Alice Motard; Hugh Mulholland; Matt Packer; Gill Park; Sara-Jayne Parsons; Laurence Taylor; Sam Thorne; Stuart Tulloch; and Axel Wieder.

The *British Art Show 8* website, britishartshow8.com, was designed and developed by digital agency Cogapp in collaboration with Fraser Muggeridge studio. We are grateful to the entire Cogapp team: Alex Bridge, Matt Chapman, Grant Cieciura, Andy Cummins, Matt Hollins, Chris How, Joshua Routh, Eleanor Rudge, Rachel Seale and Kay White. The website was project-managed by Hayward Touring Assistant Curator Antonia Shaw, with the guidance of Douglas McFarlane, Senior Web Producer, and input from Natasha Vicars, Content Manager, as well as a host of Southbank Centre staff. Lastly, we would like to thank all our contributors in advance, who will be adding to the website content whilst the exhibition tours from city to city.

At Leeds Art Gallery our first thanks are due to Programme Curator Sarah Brown, whose judgement, energy and unswerving optimism have enabled us to overcome virtually every obstacle. We have worked with her closely on the installation and other crucial aspects of the exhibition including the Strategic Touring Programme application and its realisation. We also thank John Roles, Head of Leeds Museums and Galleries; Catherine Hall, Head of Sites and Audiences; Elizabeth Hardwick, Marketing and Audience Development; Jane Bhoyroo, Freelance Exhibition Curator; Nigel Walsh, Curator – Contemporary Art; Natalie Walton, British Art Show 8 City Coordinator; Andrew Cole, Head Technician; Amanda Phillips, Learning and Access Officer; and Jude Woods, Assistant Community Curator.

The exhibition at Leeds Art Gallery would not have been possible without solid support from Leeds City Council, and we thank especially Judith Blake, Leader of Leeds City Council and Portfolio Holder, Culture and Economy; and Cluny Macpherson, Chief Officer, Culture and Sport. Many others have contributed to the realisation of *British Art Show 8* at Leeds Art Gallery and the celebration of the visual arts in Leeds. The public programme accompanying the exhibition has been produced in partnership with Leeds Beckett University, University of Leeds, Leeds College of Art, The Henry Moore Institute, Huddersfield Contemporary Music Festival and Northern Ballet. The Gallery also thanks colleagues at The Tetley, Pavilion and East Street Arts for their programmes on the occasion of the opening of the exhibition. We would also like to thank Opera North for their support for Cally Spooner's work. *British Art Show 8* in Leeds is sponsored by Investec Wealth & Investment. We would like to thank Rowena Houston, Senior Investment Director, and Dawn Cowderoy, Senior Marketing Manager.

The Edinburgh showing has involved collaboration with colleagues at three galleries and we especially thank those who have worked with us, firstly for committing to the exhibition and helping to steer the project conceptually as well as practically: John Leighton, Director-General, National Galleries of Scotland; Simon Groom, Director, Scottish National Gallery of Modern Art (SNGMA); Lucy Askew, Senior Curator, SNGMA, who is coordinating the Edinburgh showing and representing all three venues in communications with Hayward Touring; Keith Hartley, Chief Curator and Deputy Director, SNGMA; Paul Nesbitt, Director and Curator of Exhibitions, Inverleith House; and Pat Fisher, Principal Curator, Talbot Rice.

On the realisation of the exhibition and associated activity we also thank at SNGMA: Richie Cumming, Outreach Officer; Mairi Lafferty, Daskalopoulos Curator of Engagement;

Claire Walsh, Curatorial Assistant; Lee Haldane, Marketing Manager; Christopher Ganley, Digital Content & Design Manager; Cai Conduct, Senior Art Handling Technician; Lorraine Maule, Paintings Conservator; Kirsten Dunne, Paper Conservator; Siobhan McConnachie, Head of Education; Joanna Cook, Collection Services Manager; Colin Blakebell, Facilities Manager.

At Inverleith House: Chloe Reith, Curator of Exhibitions; Roween Suess, Creative Scotland Curatorial Trainee; the Trustees and Regius Keeper of the Royal Botanic Garden Edinburgh.

At Talbot Rice: James Clegg, Assistant Curator; Stuart Fallon, Assistant Curator; Lucy Brown, Gallery Manager; Tommy Stuart, Technician; Claire Hills, Gallery Assistant; Clare McAllister, Curatorial Graduate Trainee (Equality and Diversity).

The Edinburgh showing of *British Art Show 8* would not have been possible without generous funding by Creative Scotland, and we thank especially Amanda Catto, Head of Visual Arts, for her consistent support.

The exhibition in Edinburgh has been made possible with the assistance of the Government Indemnity Scheme provided by the Scottish Government.

We thank colleagues at Norwich University of the Arts (NUA) and Norfolk Museums Services. In the first instance Professor Neil Powell, Pro-Vice Chancellor, NUA and Harriet Loffler and Hannah Higham, Curators of Modern and Contemporary Art at Norwich Castle Museum & Art Gallery, have participated in our discussions with partners. Professor John Last, Vice-Chancellor, NUA and Steve Miller, Head of Norfolk Museums Services, gave us a firm commitment at an early stage which enabled us to proceed with confidence.

By convening regular meetings of a *British Art Show* steering group well in advance, the Norwich consortium has ensured that preparations are effectively coordinated with other arts organisations in the city and we are grateful to the members of that group for the thought they have given to the project over the past year: Graham Creelman OBE, Pro-Chancellor, NUA and Chair of the Steering Group; Sarah Hamilton, Director of Marketing, NUA; Esther Morgan, Relationships Manager, Norfolk Museums Services.

Other members of the steering group include Charlotte Crawley, East Anglia Art Fund; William Galinsky, Festival Director, Norfolk & Norwich Festival; Amanda Geitner, now Director of the East Anglia Art Fund; Lis Jennings, Head of Communications; Norfolk & Norwich Festival; Alison McFarlane, Executive Director, Writers' Centre; Nikki Rotsos, Executive Head of Customers, Communications and Culture, Norwich City Council; and members of the OUTPOST committee.

At both key venues we would like to thank: Louisa Milsome, Gallery Officer, NUA; Polly Neave, Personal Assistant to the Pro Vice-Chancellor, NUA; Stuart Anderson, Marketing and Communications Manager, NUA; Rosy Gray, Exhibitions Coordinator, Norwich Castle Museum & Art Gallery; Jordan Bacon, Digital Services Coordinator, Norfolk Museums Service; the Technical Design and Marketing teams at NUA; and the Design & Technical, Conservation, Marketing and Learning teams at Norwich Castle Museum & Art Gallery.

The showing in Southampton marks a key moment in the evolution of the arts in Southampton, and will be the opening exhibition at the new premises of John Hansard Gallery. Substantial support for this has been provided by the University of Southampton, Arts Council England and Southampton City Council, and the collaboration with

Southampton City Art Gallery to host the *British Art Show* establishes a firm commitment to partnership working at all levels within the city. Sincere thanks are due to several individuals at both the University of Southampton and Southampton City Council for support and advice along the way: Jane Savidge, Victoria Way, Anne Edwards at the University of Southampton; Mike Harris and Lisa Shepherd at Southampton City Council. Thanks are also due to other arts partners and organisations within the city who will be working alongside the two main venues to deliver a wider programme of events, including: City Eye, aspace, Solent Showcase.

Special thanks must go to all staff at both venues for their hard work and enthusiastic commitment; the co-ordination of the showing in Southampton has been led by Ros Carter, Dan Matthews and Jessica Whitfield. At John Hansard Gallery, University of Southampton, we would like to particularly thank: Stephen Foster, Director; Ros Carter, Head of Exhibitions; Ronda Gowland-Pryde, Head of Education & Access; Jack Lewis, Press and Marketing; Nadia Thondrayen, Programming Coordinator; Julian Grater, Gallery Technician; Val Drayton, Special Projects Manager; Amy O'Sullivan, Development Manager; as well as all other staff involved in installation, administration, and front of house. At Southampton City Art Gallery thanks go to: Dan Matthews, Lead Exhibitions Officer; Jessica Whitfield, Exhibitions Officer; Stu Rodda, Exhibitions Officer; Andrew Ball, Exhibitions Officer; Joseph Hill, Technician; Liza Morgan, Senior Learning Officer; Tim Craven, Curator of Art; Rebecca Moisan, Conservator; Gareth Colwell, Press & Marketing.

The Southampton showing is made possible by the support of the University of Southampton and Southampton City Council.

Hayward Touring would also like to thank the following individuals: Andrew Bonacina; Monica Chung; Sam Clarke; Ann Demeester; Saim Demircan; Tony Hofman; Beth Greenacre; Lisa Le Feuvre; Philip Miles; Elizabeth Sobczynski; Tom Trevor; Simon Wallis.

At Southbank Centre, thanks are owed firstly to Ralph Rugoff, Director, Hayward Gallery, for his invaluable guidance and help in shaping the project at every stage. The amazing Hayward Touring team, Gilly Fox and Antonia Shaw, Assistant Curators, and Marta Zboralska, Curatorial Assistant, have put heart and soul into organising the exhibition. Sarah O'Reilly, Hayward Gallery Manager, has given vital administrative support, with help from Andrew Caddy, Arts Business Partner. Lucy Biddle, Interpretation Manager, has written the exhibition guide and labels and provided editorial help with all written texts. Chelsea Pettitt co-organised the exhibition as Assistant Curator in its earlier stages, and Charlotte Baker joins the team as Curatorial Assistant at its opening. We thank the Hayward Publishing team for their open and efficient response to the curators' and the designers' proposals, particularly Ben Fergusson; Art Publisher, and Diana Adell, Publications Coordinator. Others at the Southbank Centre who have made important contributions include: Grace Beaumont, Sarah Cashman, Hayward Administrators; Chris Denton, Marketing and Communications Director; Helen Faulkner, Marketing Manager; Helena Zedig, Deputy Head of Press; Filipa Ferreira Mendes, Harriet Black, Press Officers; Alison Maun, Bookings and Transport Administrator; Imogen Winter, Charlotte Booth, Registrars; Marcia Ceppo, Operations Coordinator; Thomas Malcherczyk, Operations Manager; Mark King, Senior Installation Technician; Peter Brown, Steve Bullas, James Coney, Dave Palmer, Peter Phillips, Senior Transport Technicians; Alison Bowyer, Head of Grants and Trusts; Hannah Morrison, Grants and Trusts Manager; Shân Maclennan, Deputy Artistic Director; Sunita Pandya, Deputy Director of Producing and Presentation; Georgia Ward, Head of Site Design; Chiedza Mhondoro, SOCL Trainee; Bea Colley, Participation Producer; and Michal Obuchowski, Events and Collections Systems Manager.

Colleagues from various Southbank Centre departments have also supported the development of *British Art Show 8* website: Robbie Brander, Head of Infrastructure; Lisa-Marie Brown, Website Manager; James Cowdery, Head of Digital Engagement; Rob Gethen Smith, Chief Information Officer; Matthew O'Donoghue, Website Producer; Lucie Paterson, Website Project Manager; Lani Shamash, Website Project Manager; Sarah Toplis, Digital Producer; Paul Vulpiani, Head of Digital Solutions; and Pete Woodhead, Social Media Producer.

Finally and especially we thank Alan Bishop, Southbank Centre CEO, and Jude Kelly, Artistic Director, for their consistent encouragement and support.

Roger Malbert, Head of Hayward Touring

Published on the occasion of the exhibition
British Art Show 8

Leeds Art Gallery
9 October 2015 – 10 January 2016

Scottish National Gallery of Modern Art,
Inverleith House, Royal Botanic Garden Edinburgh,
and Talbot Rice Gallery, University of Edinburgh
13 February – 8 May 2016

Norwich University of the Arts
and Norwich Castle Museum and Art Gallery
24 June – 4 September 2016

John Hansard Gallery, University of Southampton
and Southampton City Art Gallery
8 October 2016 – 14 January 2017

Exhibition curated by Anna Colin and Lydia Yee

Exhibition organised by:
Head of Hayward Touring: Roger Malbert
Assistant Curators: Gilly Fox and Antonia Shaw
Curatorial Assistant: Marta Zboralska

Catalogue texts written by Lucy Biddle, with additional
texts by Gilly Fox, Antonia Shaw and Marta Zboralska

Exhibition supported by:

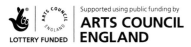

The Henry Moore
Foundation

This exhibition has been made possible by the
provision of insurance through the Government
Indemnity Scheme. Hayward Gallery would like
to thank HM Government for providing Government
Indemnity and the Department of Culture, Media
and Sport and Arts Council England for arranging
the indemnity.

Published by Hayward Publishing
Southbank Centre
Belvedere Road
London
SE1 8XX, UK
www.southbankcentre.co.uk

Art Publisher: Ben Fergusson
Sales Officer: Alex Glen
Publishing Coordinator: Diana Adell
Proofreader: Tamsin Perrett

Catalogue designed by Fraser Muggeridge studio

Printed in Spain by Grafos

Front cover: Caroline Achaintre,
Mother George, 2015 (detail)
Back cover: Magali Reus,
Leaves (Tricks, September), 2015 (detail)
Inside front cover: James Richards,
Raking Light, 2014 (detail)
Inside back cover: Daniel Sinsel, *Untitled*, 2015 (detail)

Distributed in North America, Central America
and South America by D.A.P./Distributed
Art Publishers, Inc.
155 Sixth Avenue, 2nd Floor, New York, NY 10013
tel: +1 212 627 1999
fax: +1 212 627 9484
www.artbook.com

Distributed in the UK and Europe,
by Cornerhouse Publications at HOME,
2 Tony Wilson Place, Manchester, M15 4FN
tel: +44 (0)161 212 3466
fax: +44 (0)161 236 9079
publications@homemcr.org
www.cornerhouse.org/books

HAYWARD TOURING
**SOUTHBANK
CENTRE**